The
LITTLE BOOK
of *Big*
Dreams

The
LITTLE BOOK
of *Big*
Dreams

True Stories
about People Who
Followed a Spark

ISA ADNEY

SHE WRITES PRESS

Published 2023
Printed in the United States of America
Print ISBN: 978-1-64742-585-2
E-ISBN: 978-1-64742-586-9
Library of Congress Control Number: 2023909531

For information, address:
She Writes Press
1569 Solano Ave #546
Berkeley, CA 94707

Interior Design by Tabitha Lahr

She Writes Press is a division of SparkPoint Studio, LLC.

For Cam and Hadley

CONTENTS

Part 2: *the growth*

Part 3: *the pain*

INTRODUCTION

*"When I say hope, I don't mean hope for any-
thing in particular. I guess I just mean thinking
that it's worth it to keep one's eyes open."*

—Maggie Nelson, *Bluets*

This book was born on a bathroom floor.

Eight years ago, I was rejected from a Harvard doctoral program in educational leadership; since it was a fully funded program and one of the only of its kind, it was the only one I applied for. It was a long shot anyway. Me, Harvard? Please. But I was lost and searching for my next dream. And throwing spaghetti at the highest ceiling I could think of seemed like a good way to get unlost, and maybe even score the kind of validation and credibility I always felt was missing when others looked at me, a petite half-Puerto Rican girl.

I didn't allow myself to *really* believe I'd get into Harvard, even after applying. But when I got the email notifying me that I was one of only fifty applicants being asked to fly to Cambridge to interview, I was truly

shocked and *incredibly* elated. For the first time in my life, I let myself hope higher and dream bigger than I ever had.

I flew from Florida to Cambridge; my one green coat took up practically my entire suitcase. I arrived the day before the interview, dropped off my luggage at a Harvard Square hotel, and walked across the street to try my first warm lobster roll. Then I joined a Harvard campus tour, during which I rubbed the worn-bronze part of John Harvard's shoe for good luck, just like the campus tour guide recommended. Before turning in for the night, I bought a maroon Harvard beanie and wore it out of the store and into the snow.

The next morning as I put on my green coat and walked to the interview, I thought about my grandma Isabel, how she'd moved from Puerto Rico to New York to work as a seamstress with less than a high school education, raising her siblings after her mom died, and how I had come to be the first in our family to graduate with a bachelor's degree. When I graduated with a master's degree, she mailed me a bright blue card that said, "*Aspiraste a lo alto*"—loosely translated: "You aspired high." She died the day my master's diploma arrived in the mail.

Up to that point in my life, education always felt like my best chance to aspire higher, dream bigger, and maybe even blaze a few trails the way my grandma had done for me.

All throughout the Harvard interview process, I felt like I was breathing in a new atmosphere. I felt alive, like anything was possible, like big dreams really could come true. I flew back home to Florida feeling like I actually had a chance, like everything was about to change.

And it was. But not in the ways I expected.

A few weeks later, I got the "we regret to inform you" email. My first thought was how embarrassing it was going to be to have to tell everyone on social media—where I had posted about the interview and shared lobster roll photos—that I didn't get in, that I'd reached too high and fallen.

That night, as reality sunk in, I retreated to the bathroom to be alone with my shame, my disappointment, and my raging self-doubt.

This was only one rejection, of course, and if that one program really *had* been my dream, I could have applied again, just as one of the program directors encouraged me to do; many alumni told me they applied multiple times before getting in. And, when it came to getting a doctorate or even making an impact in education, there were so many other ways I could still do that outside of Harvard.

But I considered none of that as I slowly and violently broke down on that bathroom floor. Because this breakdown wasn't really about Harvard or graduate school. None of this was. It was a reckoning of whether I believed dreaming big was worth the pain it can cause; of whether I thought I needed validation or credibility to go for my biggest dreams; of whether I was really brave enough to admit how I'd changed and how what I really wanted had changed. Up until then, I'd been avoiding those questions by climbing a ladder I thought I was supposed to climb. I was so focused on proving something, or proving myself, that I lost touch with my real dreams.

As I crouched on the bathroom floor and wept that night, I didn't have this clarity yet. And while now one

rejection letter seems like a trivial reason for me to break down, at the time it was my first real slap from reality, the first time I felt what it was like for a dream to expand and then suffocate. I was learning how quickly and unexpectedly, like Fantine sings in the *Les Misérables* song "I Dreamed a Dream," a dream can turn to shame.

I'd bought into the concept of Harvard being some kind of ultimate success, or at least proof of the American Dream—proof that I was enough, that I'd tried hard enough, that I'd done enough to make good on what my grandma had started. But instead of allowing myself to question the validity of some of those constructs and consider how misguided they might have been, I went straight to blaming myself—and my dreams.

If dreams were the cause of this pain, I thought, *then the only way to pick myself up off this bathroom floor and keep going is to stop being a dreamer, right?* I decided I should embrace cold reality instead.

Letting some dreams go and moving on can be an important and beautiful thing, but that was not what was happening here. I wasn't trying to let go of just one dream; I was trying to kill my very impulse to dream at all.

With knees on brown tile, I sobbed and heaved and tried with all my type A might to become a cynic. I asked myself: *What if I put all this overachieving energy into accepting the world for what it really is? What if I finally face reality and stop trying to be more than what the world tells me I am capable of? What if I stop now, give in, resign?*

If I push and pull enough, I thought, *maybe I can get resignation to look like contentment, or at least learn how to pretend.*

I wanted to stop being a dreamer.

Cynicism was loud that night, but thankfully, other voices showed up in my head that were louder—voices that had the last word, voices that ranged from true stories about dreamers from art and history I'd read about all my life to people who faced *much* more challenging circumstances and injustices than I'd ever known and who somehow, for some reason, kept dreaming anyway.

I didn't have any answers that night, and I knew I might never quite understand what it means to be a dreamer or even why we dream, but realizing I wasn't alone was enough to stop my crying.

That night I made a choice, one I've had to make over and over again since: *cynicism or courage?*

It's easy to believe in dreams when things are going your way. But if I chose to continue to dream *after* rejection, failure, heartbreak, and setback, I realized, my courage would have to grow too.

This surprised me, because it seemed dreamers were often considered soft, fragile, pie-in-the-sky people. Maybe that was wrong, or maybe it was only half the story. Maybe the other half was rugged, gritty, chaotic, and even brutal sometimes. How courageous is it then to face a sharp reality while holding a fragile dream in your hands?

I stood up from the bathroom floor, determined not so much to *be* a dreamer as to accept my dreamer side as part of who I am, how I am wired. That night I remembered *The Alchemist* by Paulo Coelho, a book random people in my life had told me about for years. It was on my list of books to read, but I hadn't read it yet. I remembered one person had mentioned that book

was about dreams, and now felt like the perfect time to read it.

I finished Coelho's beautiful allegory within days, and then became curious about what a dream journey, as described in *The Alchemist*, might look like in real life. What if I interviewed people about *their* real life dream journeys and wrote a book about it?

I felt a spark, one that offered the same sensation of hope and expansion I felt when I stepped onto Harvard's campus for the first time. But this time, the dream felt even more like my own, and I moved toward it with less expectation and more curiosity.

Inspired by my first blog, I'd written my first book a few years prior, a book about and for community college students (hence the higher education pathway I'd taken since), but this new book idea helped me see that I was ready to pivot from a career in higher education toward a creative one, closer to something I'd been doing all along—writing.

I also wondered if writing true stories about dreamers could help someone else the next time they found themselves crying on a bathroom floor, feeling ashamed for dreaming too big and falling too far. At the very least, I knew *I* could use more of those stories, so I went looking for them. I spent the next two years traveling the country and interviewing 120 people about their dreams coming true. Then, I spent the next six years turning three-quarters of a million words of transcription into the collection of true stories you're about to read.

The reason that conducting the interviews took only a couple years but writing the book took six is right here in this introduction. I struggled for years to decide how

to introduce this collection, how to make sense of the bathroom-floor breakdown, especially when I started to feel so privileged and frankly stupid for letting a Harvard rejection become such a painful turning point in my life.

After the joy and adventure and sense of purpose of the interview process subsided, I felt lost again. Now that I knew I no longer wanted to pursue a career in higher education, I worked odd jobs to support my writing—working at a retail surf shop, mopping floors and selling memberships at a boutique fitness studio, and even a writing a little bit as an online freelancer. But I still struggled to figure out a plan. How would I consistently pay the bills and pursue my dreams? I knew the book was going to take time, and I knew making a living as an author was almost impossible. Honestly, making a living as any kind of writer started to feel unreachable as the media landscape shifted and writing started becoming something most people did (and read) for free.

In trying to make sense of the dream stories I'd collected, I started to lose touch with my own story and my own dreams again, especially when some of my dreams started to die slow deaths in ways I never saw coming, due to things far outside of my control—a global pandemic alongside close family members' diagnoses of dementia and cancer, to name a few.

On my worst days, I'd sardonically joke to my husband that my new book would be called *Dreams Die Every Day*. Sometimes I wondered if this book itself was a dream that should die. How could I write a book about dreams in a world like this, where so many people's dreams are stolen every day? What was the point of all that dreaming, all that courage, if most of the time it

only set us up to hurt more? In the coming years I cried on bathroom floors again and asked the same questions again. Sometimes I still wished I wasn't a dreamer, that I wanted less, could settle for less, or that I didn't feel the need to try so hard so much of the time.

But I had learned something from all of those interviews. I'd learned to simply let those feelings pass through, knowing it was okay to grieve, that this was part of the process, and that maybe these low moments were a sign I did need to let *something* go (usually self-doubt, perfectionism, someone else's opinion, or an old dream). Or maybe I just needed to take a break.

As more years passed and I *still* struggled to create this book, I thought maybe I did need to scrap it, that maybe I should give up, that maybe it shouldn't exist, especially in a world where so many dreams never come true. But then I got a text that changed everything.

It happened the summer of 2022, on a brisk June evening in Vermont. It was eight years after the bathroom-floor breakdown, and I was in the dorm room of my first in-person residency for the MFA in creative nonfiction I had decided to pursue instead of a Harvard degree. I hoped to find some clarity at this summer residency. I hoped the purple leaves and green mountains outside my always-open window and the spontaneous breakfast conversations about lyric essays would help me finally figure out if this book was worth finishing, worth sharing.

On one of the first nights of the residency I received a text from my best friend Erin (whose story is featured in Chapter 1). Erin's text said that her eight-month-old niece Cam, the one we'd joyously talked about every time we'd hung out, had just died in a car accident. The

car Cam had been riding in was rear-ended by someone going seventy miles per hour; the driver died that night too. Erin's sister Megan and her husband were in the front seat; they were injured, but made it out alive.

I read the text twice and couldn't move. I stood still in that dorm room, suspended on the third floor in an old brick building, surrounded by pale cinder-block walls, holding my phone, feeling like I was falling through the worn-flat blue carpet. I don't know how long I stood there, but I finally moved when I heard a persistent beating noise above my head. I looked up to find a winged bug flinging itself against the only fluorescent light in my room. Panicked, I turned off that light and the small lamps for good measure, opened the door to the brightly lit hallway, and waited in the dark, hoping the bug would follow the light and leave me alone.

It did.

A few minutes later, I peeked into the hallway, curious to see where it ended up. The only sign of life I found was a tiny red ladybug calmly hanging on to the hallway light.

Erin loves ladybugs. I gave her a silver bracelet with a ladybug charm once, not knowing she already had one in gold, but she proudly wears both at the same time. She thinks of ladybugs as a happy sign: a promise of good luck, of hope. When I was in New Smyrna Beach just five months before that text, staying in a hotel while doing my winter residency remotely, I bought two tiny glass ladybugs at a gift shop—one for her and one for me. They each came with a small card that said, "This tiny little ladybug, though small as it may be, is filled with loving wishes just for you from me." She told me

months later that her four-year-old daughter Ella loved to cradle it in the palm of her hand.

I marveled as I stared at this real ladybug on the light. I truly didn't know if the scary bug flew away once it got into the hallway and the ladybug took its place or if it was a ladybug crashing into my light all along.

I went back inside my room and locked the door. I turned on a light. I couldn't sleep. I couldn't stop thinking about something else Erin said in her text, about how her sister Megan, who had always firmly and assuredly only wanted one kid, had already declared, even in the tumult of the unimaginable, her plans to now have two more kids.

While my instinct upon even a trivial loss was to stop dreaming altogether, Megan's response to a tragic loss was to dream bigger. And after a loss like hers, she'd have every right to hate the world, to never dream again, to choose cynicism, to scream and grieve and cry for the rest of her life. And her new dream, of course, was not to replace what she'd lost—she knew she could never do that—but it seemed to me that a dream dreamed in the worst moment of her life reflected a kind of defiance. The world may have stolen her daughter, her dream, but it could not steal all that Cam had already left behind, including a space in Megan's heart for dreaming again, a space Cam made bigger, a space even loss couldn't close up. Megan's response helped me consider for the first time that perhaps a dream, no matter *how* it ends, can open up new space that neither reality nor loss can undo.

I struggled with this book for eight years because I couldn't reconcile how to honor loss and hope at the same time or how to celebrate dreams and dreamers in a cruel, unjust world where so much is out of our control.

Megan and Cam helped me realize that dreamers deserve to be celebrated *within* the loss, *on* the bathroom floor, and in the midst of all that is outside of our control—because that's what makes dreaming brave, and that's what kept me returning to these stories and this book again and again.

The stories in this book are not about people getting everything they ever wanted. They're not about their perfect lives or how you too can have a perfect life, or even a perfect dream come true. These are stories about people who tried to bring a dream to reality, who faced the unknown, grappled with all they could not control, and kept going, holding on to a spark of hope that maybe each loss, each bathroom-floor breakdown, did not have to be the end of the story if they didn't want it to be.

I'd be lying if I said there aren't times when I still find myself crying on new bathroom floors. But sometimes we need to feel the cold tile again, to rack and heave and grieve before we're ready to dream again.

And sometimes, we need help.

I have yet to meet or read about anyone who had a dream come true without help, and I think some of the greatest heroes in dreamer stories are the people behind the scenes, who help and encourage and open doors along the way. For me, and this book, one of those heroes is Jenny.

Jenny is a transcriber for a company I hired to transcribe the interviews early on in the process. Jenny emailed me out of the blue during those first few years of the project and wrote: "I have been transcribing several of your interviews with people for your new book and I just felt the need to email you because it has made

a difference in my life. Hearing these different people's stories about their dreams is inspiring me to keep going to work toward mine."

I handwrote that email in pink marker on a blank piece of paper and taped that piece of paper to the bathroom wall of my apartment in California. Today, that piece of paper and the flowered tape that held it are preserved behind glass and framed on the wall of my writing office in Florida. I've never met Jenny, but she kept me going, and so did the people whose stories are in this book. I hope you find in them whatever you need most right now when it comes to your biggest dream or that tiniest, faint spark you can't even name yet.

Through these stories I learned how to recognize the beauty that can be found even in the dark, what I *can* control when it comes to my dreams and how to let go of what I can't, how to reckon with dreams that die and not let loss blind me to the possibilities of new dreams, how to grieve losses without turning dreams into shame, and how to keep going even when I'm weary and filled with doubt. Crying on a bathroom floor isn't a sign you're doing it wrong—it's a sign you're alive.

The short stories in this book are about people who decided to follow a spark and how that spark turned into a dream come true. Each story was written from an interview I did, some in person, but most often over the phone or on a video call, and each is true to wherever that conversation went when I asked them to tell me about a dream come true in their life and how it came to be.

The interviews began with people I knew and then snowballed from there as they recommended dreamers *they*

knew who might be willing to talk to me. I also reached out cold to dreamers who inspired me. I was blown away by some of the people who said yes and deeply grateful to everyone who generously gave their time to an unknown author with her own dream. Everyone I interviewed has since become a good friend, and I hope by the end of this book they feel like friends to you too.

The chapters reflect the themes that emerged over and over again throughout my conversations with all 120 interviewees, as well as the additional research I did over the last eight years. Not every story could fit in the book, but every interview informed the themes. The stories featured here are the ones that best illustrated the themes that were present in every interview.

While many of the stories could work thematically in multiple chapters, I carefully chose and placed each one according to its ability to best illustrate a particular idea or obstacle. All I can do is show you what I saw and what inspired *me* most, but what really matters is what *you* see in each of these stories.

Every story in this book kept me going when I felt like giving up, but there is one story that helped me get through the last bouts of doubt I had about sharing this book, one last story I couldn't get out of my head.

Yours.

Your story is the most important one in this book, and I hope the stories you find here help you keep going toward whatever dream you follow next.

Part 1:

the spark

"It's the possibility of having a dream come true
that makes life interesting."

—Paulo Coelho, *The Alchemist*

Chapter 1:

FIRST STEPS

The dream begins.

✴ FINDING YOUR DREAM
(SUZ LOSHIN)

Suz Loshin's dream sparked in her grandma's dark, musty TV room, which held two giant recliners and a dresser with secret chocolates stashed in its drawers. Suz was twelve years old, watching a movie with her grandma and mom, and on the screen that night was the 1961 film *Splendor in the Grass*. It made Suz *feel* something; it was the first time a movie shifted her lens on life.

"I remember being rocked by it," she says. "This is a story where nothing really works out, but it is beautiful."

When the movie ended and the credits rolled, Suz felt a spark of pure enjoyment that turned into wonder, then yearning. For Suz, it sounded like this: *I want to do that. I want to be part of that.*

She wanted to create that kind of beauty *herself*. She wanted to make movies, tell stories, and have her name scroll up the credits in the dark. She didn't care if anyone knew or noticed her name, but she wanted to be one of the people who made the stories happen.

So when it came time for college, she applied and got into film school. There was only one problem: she didn't know what she wanted to *do* in film. There are *a lot* of people in those credits. Which one did she want to be?

She was confident in the foundation of her dream, but struggled to identify or categorize it, and the world seemed to need her to do so. She tried to figure it out, asking herself questions and trying everything she could. *Do I want to be a writer, an actor, a producer, a director?* she wondered.

"I just dabbled in it all," she shares.

But none of the dabbling sparked anything *specific*.

"There was never one thing," she says, "that was like, *This is it.*"

It was confusing and even daunting at times, but instead of forcing herself to choose something for the sake of choosing, Suz prioritized the exploration process and made peace with the uncertainty. She kept her options open and stayed curious, always asking herself questions after every new film experience, such as: *What did I love doing?* and *What was I good at?*

With the pressure off, she dove deeper into the work, following whatever she was drawn to, whatever she was loving. And instead of imposing a strict definition on her dream, she let herself gravitate toward the things that moved her forward, staying open to whatever that might be, and however it might change.

After a few years in film school, she still couldn't identify *exactly* what she wanted to do. She thought it would be a good idea to get even closer to the "real" thing, so every summer in college, she left her film school in Boston for Los Angeles and worked any film production internships she could get. She was giving herself a kind of test to find out what would happen to her spark if she threw herself into the fire.

The jobs were harder than she'd imagined.

"You are at the bottom of the bottom," she says of being a production assistant, "working in a field everyone seems to want to go into. It was physically and emotionally demanding, and utterly draining."

But she thrived.

"I *loved* the endurance it required," she says, "the power it forced out of me. I *liked* the challenge, and it solidified it all for me. I was like, *I'm 100 percent in and I'm going to do whatever it takes.*"

Suz graduated from Boston University with a degree in film and got a few jobs with local production companies, many led by women. They showed her, she says, what it looked like to go the distance.

"I realized you've got to put yourself out there if you want to be in a leadership role," she says. "It also helped me learn how to work really hard and develop stamina. I watched really great production assistants come in and do it for a year or two, and then say, 'This blows' and leave. I was just like, *I'm going to stick it out.*"

She didn't think they were weak for leaving, though; it *was* really hard work (and working conditions for film crews really *did* need reform), but her reaction showed her that she really *did* want this, even though she still couldn't quite define what exactly she wanted to do. She didn't know what was on the other side of this spark, but she still felt like the mystery was worth it.

But then, the 2008 financial crisis hit and the film job market looked uncertain. Suz moved back home to San Francisco, where a family friend offered her a job at his growing music startup. She took it.

"My philosophy," Suz says, "is to be flexible, because you never know where life is going to take you."

She really needed a job and figured it couldn't hurt to save up some money so she could move somewhere closer to the film industry again soon. She thrived in the startup environment, where success wasn't about finding your "one thing" or staying in your lane. Instead, she says, she found "so much flexibility in unassigned roles."

But then one day Suz ran into an old neighbor, someone she'd once told about her longtime dream to work in film.

When he found out she was working in music he said, "Why the heck are you working in music? You wanted to be in film." He knew someone who worked at the nearby computer animation film studio and said, "Send me your résumé. It's a long shot, but I'm going to pass it on to someone I know at Pixar."

Suz got an interview at Pixar.

And another.

And another.

Suz did fifteen interviews at Pixar; they didn't interview her for a particular job opening, but they wanted her to make the rounds to see if there might be a fit when the right project opened up for someone with such an extensive résumé as a production assistant. But five months went by and Suz heard nothing.

And then the right project opened up.

Suz was hired as a production assistant on a new film they were working on, the first Pixar film to feature a female protagonist—*Brave*.

Her production assistant experience, startup experience, and passion for stories got her the job offer, but she was really grateful for her neighbor and that she'd once told him her dream.

"I got really lucky in that sense," she says. "This is an industry of a lot of favors and people helping each other, and that is something I don't ever forget. If someone reaches out to me for help, I'm like, *absolutely*, because you never know when you are going to need help.

"I certainly needed help along the way. I rarely meet anyone successful who hasn't had a ton of help and luck. It's really easy to be like, 'I don't need help and my work will speak for itself,' but everyone needs help."

At Pixar, Suz felt like she was getting closer to her dream, but she also felt a little discouraged at times; this new role was actually a demotion from her music job. She was back to being a lowly production assistant. Sometimes moving closer to a dream feels a lot like having to start over.

But Suz held fast to the hope that this *was* a step forward, even if sometimes it felt backward. Suz gave her all to her Pixar job, helping however and wherever she could. For *years*.

After three years, though, even she started to get weary. The production process on *Brave* stalled a few times, as it often does, and in turn *she* felt stalled. But she didn't know what else to do but to keep working and hoping that somehow, something would change.

"I was proving myself," she says of her mentality at that time, "and hoping for a miracle."

Some directorial changes were made to the film, and Suz's work ethic *was* noticed. She got promoted to assist one of the new directors of *Brave*, Mark Andrews.

"It felt amazing to feel a sense of forward movement and opportunity," she says of that promotion. "I don't think anyone wanted it more than I did. I was ready to

go, and I worked even harder and loved every minute of it. I loved even the toughest parts because I had fought so hard to be there."

That love, the one that sparked in that musty TV room, is what kept her going. The pure joy of being part of what she'd always longed to be a part of sustained her.

After years of work, *Brave* was finally complete, and Suz's final task in that role was to help plan the wrap party and premiere for the company and crew, including the Pixar and Disney executives who would attend.

Since *Brave* was set in Scotland, Suz dreamed of having the premiere party outside a castle, under the stars. "I have very lofty goals and dreams about stuff like this," she says with a smile.

She wasn't afraid of moving toward dreams that were big and hazy; the goal didn't need to be super clear to get her going. So she drove around the Bay Area looking for a castle, and eventually she found something that fulfilled her vision.

It was in Calistoga, over an hour away from Pixar's Emeryville campus, but it was perfect. Staging the premiere there wouldn't be easy, but Suz was not put off by difficulty. She commissioned an outdoor theater to seat a few thousand people in front of the castle, and directed the crew to build it in *just* the right spot so the audience could see the mountain range behind the castle as they watched the film.

On the night of the premiere, everyone gushed over the castle and the view Suz had so carefully picked to commemorate the end of their seven-year journey making a movie together. Suz cared about every detail; for her, every part was meant to tell a story.

"We had this incredible party that was like a Renaissance fair, with archery, face painting, and turkey legs," she says happily.

Her mom also attended as her guest. Once the festivities wound down and it was time to start the film, like so many times before, Suz sat beside her mom to watch a movie.

When the movie started—and Suz assures me this is true—Suz saw a shooting star.

When the movie ended, and the credits rolled, Suz's name was there, projected on a screen in front of the castle she had found, beneath a starry sky.

★ WHERE TO START
(MELISSA CORP)

Melissa Corp and her daughter always laughed when they noticed they were both wearing mismatched socks. It kind of became their thing, something they eventually started doing on purpose.

Melissa and *her* mom, Rhoda, were avid runners, and when Rhoda died of breast cancer, Melissa got an idea to create bright, purposely mismatched socks for runners. She dreamed that part of the proceeds of these imagined sales would also go to charities, like ones for breast cancer.

There was only one problem with Melissa's new idea: she knew *nothing* about designing, manufacturing, or selling socks.

She could picture the product perfectly—the socks were so clear in her head—but she had *no* idea how to get them out into the real world. Where would she even begin?

It was so daunting that it seemed her little dream was dead before it began.

Except it wasn't. Because Melissa wasn't going to let *not* knowing how to do something stop her from doing it. She could learn, right? She could figure it out. And

she did, taking her first steps long before she had any idea about what she was doing.

"I am not really an artistic person," Melissa says, but she drew the design she saw in her head on paper anyway. Her drawing featured one bubblegum-pink sock with a gray heart in the center that said, "Strong Heart," alongside its "match"—a gray sock with a bubblegum-pink breast cancer ribbon in the center that said, "Strong Soul."

She sent that drawing to her artistic friend Sue, and Sue drew the design on her iPad so that Melissa could have a digital version.

"I am not a tech-savvy person either," Melissa says, but once she had a digital version of her design, she searched the internet for a quality manufacturer as if her life depended on it.

"I did not have the funds to really start this," she says. She reached out to the local university to find college students majoring in graphic design, who she hired to turn the iPad design into the kind of graphics the manufacturers required.

What kept her going and kept her learning was how much fun she was having.

But then her fun thing turned into a survival thing.

Melissa's marriage ended unexpectedly; she'd been a stay-at-home mom for twenty-four years, and now she needed to get a job, and fast, to help support the four kids still living under her roof.

Sometimes dreams need to take a backseat to the unexpected. But sometimes, they're just what we need.

What if this project can be more? Melissa wondered. *What if it can actually help me support my family?*

That's when this fun project officially started to feel more like a big dream, and Melissa became inspired to work even harder on it. To make ends meet in the meantime, she got a job at the local running store and worked on her socks in her off time.

After a few months, her first batch of pink and gray mismatched socks were manufactured in the United States and delivered to her door. She excitedly brought them around to show family and friends; her boss at the local running store loved them so much that she encouraged Melissa to put them on display and sell them in the store.

They sold out in four days.

"It just kind of got contagious," Melissa remembers.

People loved how comfortable the socks were and also how snug they were—perfectly fitted for runners. They also swooned over the bright, mismatched colors, and loved that buying a pair would also support a non-profit. She called her brand My Soxy Feet.

I found Melissa by way of a pair of bright green and pink mismatched socks I saw displayed on the counter of a local store as I was checking out one day. The saying in one of the middle socks caught my attention right away: "Dream Big." I picked them up and noticed the label said the socks would also support a foundation for epilepsy, something my youngest brother and a close friend both had. I bought the colorful socks immediately and reached out to Melissa that evening; I had a gut feeling they'd started as a dream and were made by a dreamer.

Melissa's dream come true was seeing her idea become something real, something physical, especially when it started as something that only lived in her head,

something she really had no idea how to make real. And now it was a thing she could hold. A thing others could hold. And a thing she could give.

What has meant the most to her so far has been getting tagged in photos of people around the world proudly showing off the socks she dreamed up on an ordinary day. That dream also helped her survive one of the most difficult seasons of her life. To date, she has created over fifty designs and supported over twelve charities. And eventually the business did become something that could support her family; she currently runs My Soxy Feet full time.

✳ WHEN TO SHARE
(ADRIANNA SAMANIEGO)

Adrianna Samaniego enjoyed her finance classes at the University of Georgia, but what *really* lit her up was the nonprofit work she was doing on the side to uplift the Latino community; *that* work made her really want to make the most of her college education, to dream big and achieve as much as she could so she could be an example and a voice for that community wherever she went.

As a finance major, she was always hearing about prestigious internships at investment banks, and she did hope to apply. But when she told her adviser her plan to apply to Goldman Sachs, they balked.

"You'll never have a chance of getting a job at Goldman Sachs," they said. "They'd never recruit someone from a state school."

But Adrianna wasn't deterred. She responded the same way she always does when someone tells her no: She says, "Alright, that's your opinion." And then she proceeds to do whatever they said she could not do, finding courage in focusing on what she does have and what no one's opinion can take away. Adrianna's philosophy is, "If you have a glass of water that's half empty, you still have a glass of water."

Adrianna got a job at Goldman Sachs.

But that dream wasn't what she thought it would be. It turned out she didn't like working at an investment bank.

So she turned to another passion; she'd always loved innovation and technology, especially the opportunities it could create to level the playing field, creating equal access to information and knowledge. She loved what Google was doing in its early days, and she decided to take the leap and apply for a full-time job there.

She got a job in the sales organization. She was good at her job, but she realized it wasn't the right fit; she wasn't passionate about it, and Adrianna really wanted to do work she was passionate about.

Google was a big company and constantly had new roles opening up. She was always looking for something else, but nothing really sparked her.

Feeling stuck but unwilling to settle, Adrianna asked herself a question: *When was the last time you felt really alive?* Her answer? It was when she was doing nonprofit work for the Latino community in college.

Instead of leaving her job, she wondered if perhaps she could bring that feeling, and that kind of work, *into* her job. What if she created a new job? What if she wrote her own job description? What if she created a whole new division, one that focused on the Latino business community she grew up in?

Google offered employees what they called 20-Percent Time, a program in which employees could dedicate 20 percent of their working hours to any project they wanted, even if that project was outside their job description. Adrianna finally knew how she wanted to use her 20-percent time.

She used that time to develop a new program for the Google Business division, one that would focus on reaching out to and supporting the Latino business community. She arrived on Google's campus at 6:00 a.m. every day to work on her project until 9:00 a.m., worked her regular job after that, and then stayed late to work even more on her own project.

Fueled by her dream for what the project could become, she essentially worked two jobs for three-and-a-half years, all the while hoping that launching the program would prove to the leadership team that her idea was viable and vital enough to turn into its own division—one she could lead.

Once the program launched, she recruited other employees to use their 20-percent time on the project. Many were inspired by her passion and excited to join. Then she pitched the project to the directors as something worthy of being more than just a 20-percent time project.

But they said no.

Adrianna thought, *Alright, that's your opinion*, and kept working on it.

She hoped if she was able to keep showing real results, eventually *someone* would see the value of what she was doing.

Months went by and nothing changed, and even she got tired.

Tired of working two jobs.

Tired of waiting for someone else to give her permission.

Tired of needing someone else to believe her idea was worthy.

So in one last-ditch effort, she decided to write her dream job description and share *that* with the directors.

In her first pitch, she'd left out her dream to start and run a whole new division. She had shared the idea but hadn't shared what she really wanted.

"It took me a long time to communicate it," she says. "I wasn't able to say to everyone, 'Look, I have this dream,' because that also tells someone you haven't made it yet, and that can be hard for a type A."

Nothing changed until she was able to admit to herself that she wasn't doing what she really wanted to do.

"One of the hardest things was looking in the mirror," she says, "and telling myself, 'Okay, the 20 percent is great, but that's not really where your heart lies. If you want to be doing this full time you can't continue to lie to yourself. You owe it to yourself to go after it and just continue to knock on every door until they give you that job.'"

After that pep talk, she decided to try just one more time with Google, this time telling the directors what she *really* wanted and showing them her fully written dream job description. But this time, she wouldn't put too much stake in their response, knowing that even though this was the last door she was going to knock on at Google, it wasn't the last door ever. *If it doesn't happen this time*, she reasoned, *after this much work, then they don't see it and they're never going to see it. I'll go to a different company or create my own thing.*

She committed to her dream in a new way—whether anyone else saw value in what she was doing or not didn't matter anymore. She saw it. And that was enough. So she shared her dream job description with Google at the end of a workday and then went home.

The next morning, she came in to work feeling freer and more at peace than she had in a long time. Instead of working feverishly from 6:00 a.m. to 9:00 a.m. as she often did, this morning she went to the meditation room instead.

That's where she got the call. She looked up, embarrassed, since this was supposed to be a quiet space. It was so early, though, that no one else was there, so she answered the phone.

It was a director, offering her a new job—her dream job, the one she wrote herself.

"Don't dream small," she tells the people she mentors now, especially those who feel trapped by the way others perceive them. "The biggest thing you can think of, that you're scared to verbalize openly? That's the right thing."

✷ JUMPING EVEN WHEN YOU'RE SCARED
(ERIN LOVELL-EBANKS)

Erin Lovell-Ebanks stared up at the ladder that would lead her to the zip line. At twelve years old, she was so excited for this summer-camp activity that she climbed the ladder joyously. But when she got to the top, she froze.

"I wanted to do it, but I couldn't," she remembers. "I came back down the ladder, and the rest of the day it ate away at me. I never wanted to feel like that again, like I was letting myself down."

That feeling of climbing back down the ladder haunted her, changed her.

"I didn't want to experience that kind of regret anymore," Erin says, "so from then on, living on the edge of my comfort zone became a thing for me."

Erin didn't have a specific dream growing up, but she did have an innate belief in possibility *and* a real fear about missing out on that possibility, of not grabbing onto the proverbial zip lines at the top of every ladder she was privileged to climb.

To combat her fear, Erin decided that going forward she would say yes to anything that excited her, even when,

or maybe especially when, it scared her too. The more she practiced doing this, the more it became a habit. Moving toward that scared-excited feeling, even when she had no idea where it would lead, became a way of life.

In college, she majored in communications because of the excitement she felt watching Kate Hudson play magazine writer Andie Anderson in *How to Lose a Guy in 10 Days*. And when a scary-exciting opportunity came up to intern at the local newspaper, Erin jumped.

But she didn't expect what happened next. She *hated* that job.

"I was so uncomfortable, and it was all so mind-numbingly boring to me," Erin remembers. "I counted down the minutes until I could leave. And I only worked there twice a week."

Erin is quick to say yes to uncomfortable things that excite her, but she is even quicker to move *away* from the uncomfortable things that bore her. "You can put yourself into a denial state by doing something you dislike or are not meant to do for too long," she says.

That job helped her learn quickly that journalism wasn't really what she wanted to do. But instead of descending into a spiral of doubt about her future, she patiently widened her eyes, hoping to catch a glimpse of anything else scary-exciting that might show up.

To help that along, she also tried things—anything that seemed even a little bit interesting, like songwriting or teaching spin classes in college. Erin *loved* college. As a little girl, she had never played house; she only played school. And when her sister Megan was unwilling to be her pupil (which was often), Erin enrolled imaginary friends. School was *always* exciting to Erin, so when

she graduated with her communications degree and *still* wasn't sure what to do next, she went to graduate school.

And that's when it happened.

A fellow graduate student walked into Erin's morning class wearing a nice skirt and blazer, the only person in class not in the typical grad-school garb of leggings, T-shirt, and oversized cardigan. Every week this student showed up in a nice outfit.

During one class, Erin complimented her skirt and, unable to keep her growing curiosity at bay, asked, "Why do you always dress so nice?"

The student shared that she was a speech teacher at the college. Erin was confused. This young woman was Erin's age and still in graduate school, so how could she be teaching at a university?

The nicely dressed graduate student explained that she was a graduate teacher, something Erin hadn't heard of before. And as the student explained what her teaching experience was like, Erin felt that bottom-of-the-zip-line-ladder feeling again. Teaching a college class sounded very exciting (and very scary). It was perfect.

Erin asked the nicely dressed student for help, and within weeks Erin was signed up to teach her first college class.

But right before walking into her first class, she was terrified; it was as if she were right back in summer camp, standing at the top of the ladder.

"I walked up the stairs to go teach my first class," she remembers, "thinking, *What have I done? What am I doing?*"

But this time, she jumped anyway. She opened the door, stood in front of all those students, and taught her first class.

Afterward, she felt something she'd *never* felt before, a distinct sense of direction, a rush, a feeling of *Oh my gosh, this is it!*

It felt similar, Erin says, to when she first met her now-husband Adam.

"You date a lot of people," she says, "and think, *This feels fine, this feels fine, this feels fine*, and then *Boom-Oh-My-Gosh-This-Is-IT*."

It's the moment you realize *more* than "fine" even exists—just when, perhaps, you were thinking of settling for fine, thinking fine was as good as anyone could hope for.

After teaching that first class, Erin called her parents, elated.

"I was so excited," she says. "I remember pacing around my apartment; I had finally found what I really wanted to do after all those different internships and jobs. It was such a crazy high. And there was no looking back."

By the time I met Erin in a Florida café, she'd been teaching college speech courses for years and was about to write a book for other professors. A mutual friend connected us because Erin was asking for help, just like she'd asked that grad student for help; she was telling people about her book and asking around for advice. Our mutual friend connected us, knowing I'd recently written a book for community college students. I didn't know then that my first book would be the reason I would meet my best friend.

Erin wrote her book, *Happy Professor*, in 2014. As one of the early adopters of online teaching, she also started a successful blog of the same name. Clearly, her early explorations into newspaper and magazine writing didn't go to waste.

It has been well over a decade since Erin taught her first class, and she's still teaching. It still feels like a dream come true, even though it wasn't something she dreamed of ahead of time.

"To me, it doesn't matter what the initial dream is or what kind of dream it is," she says. "It just matters how great it makes you feel. I didn't have this longtime dream of, *I'm going to reach for this goal and I'm going to be a teacher.* It was never that. I just wanted to be able to be myself, and teaching really allowed me to do that."

✴ BIG DREAMS START SMALL
(RONNIE CHO)

Ever since he was a kid, Ronnie Cho dreamed of working in public service, finding a job that would allow him to create opportunities for immigrants and advance social justice. Ronnie's parents left South Korea in 1980, and he was born in the United States in 1982. He remembers they were "very poor," but also "very excited to be here." They worked many jobs, sometimes traveling extensively to find work, but they were happy; they sincerely believed they were "so blessed to be in this country," and that in the United States, "if you are willing to work hard and play by the rules, anything is possible." Their life was difficult, but Ronnie saw how his parents' belief in their dream and the opportunities they believed in buoyed them. He hoped to find a job one day where he could help make those kinds of dreams a reality for people who weren't born into an environment of opportunity.

It was a *big* dream, the kind that's so big there's nothing to hold on to, nothing to anchor to the ground long enough to know it or grow into it; left too big, a dream like that can bloat like a carnival balloon and float away.

So instead, Ronnie took a pin to his big dream balloon, blowing it up into scraps small enough to fit into his hands. He decided to focus his dream on his own community, and, while still in high school, he volunteered at the local soup kitchen and became a dedicated volunteer for many local political campaigns. He also ran for student body president. (When elected, he reduced the price of prom tickets when he heard a lot of students couldn't afford to attend.)

Ronnie happily started small, but he didn't anticipate how *big* those "small" steps would feel. They fired him up.

"When you are fired up," he says, "something else takes over. You're sort of on autopilot because you're in your groove. You can't explain what happens; otherwise you would conjure it all the time. It's special when it comes about and you're in the zone."

While it's hard to hold onto that "fired up" feeling 24-7, Ronnie knew to pay attention to it. He decided next he would try to find other people who got fired up about the same things he did, people he could learn from. He applied for an internship in Washington, DC. He didn't get it.

"I was disappointed and crushed," he remembers.

But his parents sat him down for a pep talk. "We don't have a lot of money, and we can't give you those things or a fancy last name people recognize," they said, "but what we are able to do is instill a work ethic and a desire and a fearlessness that will propel you farther than anything else we could have handed down to you."

That attitude of perseverance is his greatest inheritance, he says. And with it, he kept going, focusing again on serving wherever he could in his local community.

So when John Kerry ran for president in 2004, Ronnie joined the local campaign. He was crushed when they lost, but he was thankful for the experience. He was thrilled to be so close to "the action," and be around others who cared about political change as much as he did. Despite the loss, he felt closer to his big dream than he ever had before.

It was no surprise, then, that in early 2007, when the senator from Illinois, Barack Obama, started campaigning for president, Ronnie joined that campaign right away, fully understanding and embracing the long-shot odds of Obama's candidacy. Ronnie believed in what this senator was working toward so much; he saw his parents in the plans and the speeches, and he knew, win or lose, this was a leader he could learn from. Ronnie gave everything he had to that campaign.

And when Barack Obama was elected President of the United States in 2008, he appointed Ronnie Cho as the Associate Director of the Office of Public Engagement, where Ronnie continued doing the work he'd been doing all along.

Chapter 2:

LEAVING HOME

The courage to pursue the unknown.

✳ FOLLOWING A DREAM
TO ANOTHER COUNTRY
(JOAQUIN BALDWIN)

Every day after school let out in Asunción, Paraguay, Joaquin Baldwin sat in front of his blocky custom-made PC, clicking away to make 3D animated models. He would do things like design his name in fancy gold letters and then animate them to blow up. He loved those afternoons when his time was his own, when he could create. He wouldn't have called it a dream then, but that feeling was something he hoped to capture, or rather never lose, as he grew up.

In high school, he researched the best colleges for the digital arts and applied to almost all of the ones with scholarships. The Columbus College of Art and Design offered him a scholarship that would make it possible for him to attend, so at eighteen years old he got on a fourteen-hour flight and left the only home he'd ever known to learn more about the subject he loved most.

He began in web design, but found himself drawn to the animation department, especially because of the way the people in that department seemed to collaborate instead of compete.

"I was very introverted and not very good with other people at that time," Joaquin remembers, and the

animation department suited him. He still attended his web design classes, but did animation on the side for fun. When it came time to officially declare his major, he changed it to animation.

"It finally clicked," he says, "that whatever you are having fun with in your free time is probably something you should do as a job."

After four years, Joaquin graduated with a BFA, which also meant his student visa would expire; it was time to go home. But he wasn't ready to leave, wasn't ready to stop learning. He searched for MFA programs and scholarships in hopes he might stay and was awarded a full graduate scholarship from the Jack Kent Cooke Foundation to study animation at UCLA.

In that program, Joaquin made his own animated films and showed them on the festival circuit, winning awards, even attracting the attention of agents. After he graduated, he got into a talent development program with Disney Animation. Six months later he became a layout apprentice, working with virtual cameras to set up scenes in projects like *Wreck-It Ralph*. He eventually became a full-time staff member and the director of cinematography for the animated short *Feast*, which won an Oscar in 2015.

Joaquin was also recruited to be a layout artist on a brand-new, top secret film at the time, an original Disney musical about a snow queen and her sister, called *Frozen*.

When I ask Joaquin about what a layout artist does exactly, he laughs and says it's so hard to describe that even his parents still don't quite know what he does. He does tell me about the scene in *Frozen* when Anna and Elsa sing back and forth to each other in Elsa's ice

palace, how for that scene, and others, he was a digital choreographer of sorts, staging a scene and finding camera styles that flowed well with the music and intensified the story. He'd come a long way from blowing up animated letters on his old computer in Paraguay, but he was still having as much fun.

By the time *Frozen* won an Oscar for best animated feature, Joaquin had been working on his craft for eleven years. He was proud of being a part of an Oscar-winning feature film, but his real dream come true moment wasn't Oscar night.

In fact, his dream come true isn't a moment at all, but a feeling.

"I didn't even know layout was a job until I started applying for jobs," he shares, "and now I wouldn't trade layout for anything else. Your dream changes the more you learn about it." He wasn't inspired to leave his home country in pursuit of a specific dream, he says, but rather, by an intense need to go wherever he could to learn more about something he loved.

✴ TESTING YOUR DREAM
(CARRIE HAMMER)

Carrie Hammer majored in economics in college and then took a job in advertising; she didn't love economics or advertising, but they seemed like practical choices, and Carrie is very practical.

So when she needed more professional clothes for her New York City advertising job, she decided to make her own. It was more economical and practical for her, since she'd been sewing since the first grade when she'd asked for a sewing machine for Christmas.

Carrie made her own clothes but realized her sewing skills were a little rusty. She asked a tailor for help. When she wore her homemade clothes to work every day, something happened that she didn't see coming—people stopped her on the streets of New York City to ask her where she got her clothes.

That's when she felt something she had never felt studying economics or working in advertising, something she hadn't felt since doing needlepoint in third grade—a spark. But true to her practical side, she decided to test it first, see if it had potential to be more. She researched.

She went online to see if there were any short-term courses or trainings that would help her explore this

interest in fashion a little further. And that's where she learned about a short-term summer fashion program in Paris. Just *reading* about the program fanned her spark. But it was a big leap, so she didn't do anything right away.

But then, a year later, when she was up for a raise and promotion at the advertising agency, she decided to sign up for the fashion program instead. She booked a ticket to Paris before she could lose her nerve.

The more she researched what she was *really* interested in, the more she realized how bored she was in the practical path she'd created for herself. She quit her advertising job. Then she moved to Paris for six months to complete the short-term program.

It sounds rash and romantic, but Carrie was following her own internal logic, still a deeply practical person at heart. For her, this was a test. She was not a head-in-the-clouds dreamer but a dream-scientist of sorts. She saw this short-term program as a kind of A/B test:

A: If she didn't like the summer Paris program, she would apply for another advertising job in New York.

B: If she loved the summer Paris program, she'd pursue a new career in fashion.

She *loved* the summer Paris program.

The spark turned into a flame, her interest into a big dream. And Carrie, armed with her economics background and *a lot* of bravery, decided to start her very own fashion line. She was terrified, but every time fear overwhelmed her and she wanted to turn back, she quieted fear with logic. *You're not going to die from this*, she told herself.

As scary as the dream felt, she knew the only things she *actually* might lose were money and time. And she

knew she could always find more money by getting a job. And time? Well, for her, the time she'd lose by *not* taking the leap now was scarier.

She also thought the idea of waiting for the "perfect" time was an illusion.

"There's no good time to do something," she says, "to have a baby, to go back to school, to switch careers." For her, it was never about finding the right time, but about testing the sparks, evaluating what might be worth the risk, and then taking a leap, buying the plane ticket, quitting the job, or even just sewing the next thing.

In 2014, Carrie was asked to show her line at New York Fashion Week (NYFW), where she cast "role models" to wear her clothes down the runway: CEOs, executives, entrepreneurs, and other incredible women, including the first ever NYFW model who also happened to be in a wheelchair.

The dream that started with a ticket to Paris turned into a mission that inspired many and even helped shift an industry.

✶ CONDUCTING A
DREAM EXPERIMENT
(LINN✶)

Linn grew up in the Norwegian countryside but had always dreamed of living abroad one day. She'd especially dreamed about living in New York City.

But every time she thought of her dream of living in another country, she only saw the obstacles. *How will I pack up my whole life?* she wondered. *Can I really say goodbye to everyone and everything I've ever known?*

The obstacles felt too big, too overwhelming, so she kept pushing her dream farther into the future, always keeping it at a safe distance, thinking, *One day, some day.* Until, that is, the pain of waiting outweighed the fear of what might happen if she changed something.

It happened in law school. She'd stayed in Norway to pursue a law degree, but soon felt like the walls were closing in. She felt trapped in her own life.

But she was still terrified of the idea of moving away from home, leaving everything she'd ever known. That's when she realized that somewhere along the way, her dream had gotten tangled with this sense of permanence, as if pursuing a new life required killing her old one, as

if moving away meant she could never return.

The idea of that *was* terrifying, but she thought, *What if I just live somewhere else for one year?* A year didn't feel so scary. A year didn't feel like moving away forever, leaving everything behind indefinitely.

What if it were just an experiment? That didn't sound so scary, right?

Linn decided she would move to London for one year, just a two-hour flight away, instead of the ten-hour flight she'd have to take to move to New York. She left law school, started a blog, and moved to London.

A year later she moved back to Norway, thrilled by her experiment and encouraged. She also realized dreaming in one-year increments worked really well for her, allowing her to bypass her doubt and fears of big permanent change, the ones that often pushed her into perpetual *someday* mode.

After London, she moved to New York City. Well, kind of.

Her plan was to go to New York City for six weeks. She couldn't afford staying any longer than that at the time, and she also knew it could be another experiment.

So she "moved" to New York City, as she explains it, renting a place and even getting a temporary job at a coffee shop, living life as a New Yorker for six full weeks.

"It felt like a dream come true the whole time," she says.

Now, whenever a new dream arises, she first asks herself what it would take for her to make that dream come true in one year, even if it means changing the dream a bit.

Since New York, Linn has traveled constantly. When I interviewed her, she was in Barcelona.

Dreaming in small increments has worked well for her, increasing her confidence and courage, no matter the outcome.

"Because you may also find," she says, "that what you thought was your dream wasn't your dream. But at least you'll know. At least you won't live with regret or say, 'I wish I did that.' Instead, you can say, 'I did that and it was awesome,' or 'I did that and I didn't like it.' Either way, you did something about it."

* *Name has been changed for privacy.*

✴ LEAVING TO LEARN
(SETH STEWART)

Seth Stewart was a wrestler and a football player in school, but when he got home after practice all he could think about was dance. He was transfixed by what he saw on MTV and danced endlessly at home, copying the moves of every music video.

He asked his parents if he could take dance classes. Even though the only available classes were forty-five minutes from his home in Ohio, his parents signed him up and drove him back and forth every week. Seth is grateful that his parents supported and understood, but no one else did.

"When most kids were going out," he remembers, "I was going to dance class. None of my friends really understood how bad I wanted it."

His dad had taught him, "If you want it, you gotta go get it." So Seth mowed lawns to save up enough money to go to New York where he hoped to take the most advanced dance classes.

His parents supported his dance dreams, but after he graduated from high school, they asked him to try college first. He obliged. He went for a year, but soon

realized college wasn't for him. His dream was to be a professional dancer. While leaving college wasn't an easy decision, he thought about how, "as a dancer your body doesn't last that long." After so many years of training, he was ready to get to work.

Seth left college and lived out of a duffel bag and backpack in New York City. He auditioned by day and would "just sleep wherever" each night, including abandoned buildings. He remembers that phase as "the best time of my life."

His parents felt differently.

"They had a heart attack," he laughs.

Within six months of beginning his homeless-by-choice New York City life, he started booking small gigs as a dancer. Then, he got the chance to audition for a tour with Madonna.

Seth was talented and was often the best dancer in his classes, but at the Madonna audition, he was surrounded by dancers who were also the best dancers in *their* classes. He went through the entire audition process and gave it his all, but everyone at that audition was *so* good; he didn't have high hopes.

After that audition, Seth went back home to Ohio. He was out of money.

The next day, he got a call. He got the Madonna touring job.

After that tour, he continued going on auditions of all kinds. He took acting classes to try to expand his options. It worked. He soon landed a role as Graffiti Pete in what was then a little off-Broadway project by a relatively unknown playwright, Lin-Manuel Miranda. The musical was called *In the Heights*.

At 2:53 in the final song of the original Broadway cast album of the *In the Heights*, you can hear Seth say, "Great sunlight this morning," just before one of the musical's key turning point scenes.

In the Heights went on to Broadway, won four Tony awards, and was turned into a feature film directed by Jon M. Chu. (Seth and some of the other original cast members were in the movie too; he plays the bartender in the club dance scene.)

But when Seth got the role of Graffiti Pete for this off-Broadway production, he had no idea where it would lead. For him it was just one more chance to dance.

When *In the Heights* first moved to Broadway, Seth was the first one to show up to the Richard Rodgers theater on the first day of rehearsals. When *In the Heights* producer and director Tommy Kail saw Seth that morning, he pulled Seth aside and said, casually, "Hey, come outside real quick."

Seth followed Tommy out into the streets of New York City, just outside Broadway, and into Times Square, where Seth looked up in shock to see why Tommy had led him on this mystery walk.

Above them, a seven-story billboard was being put up, advertising *In the Heights*, with a full image of Seth as Graffiti Pete, leaning back with his eyes closed and mouth open, as if joyously shouting into the New York City skyline.

The billboard stood not too far from the train locker he'd once used to store his backpack on the nights he slept on streets.

As soon as Seth saw the billboard, he called his mom: "Yes, they're putting it up right now, with a crane! There's

flashing lights around it. You would have a heart attack." Then he told his mom, "Hold on, Mom, hold on."

I saw this moment play out in the PBS documentary *In the Heights: Chasing Broadway Dreams*, produced by Andrew Fried. In the scene, Seth puts the phone down and puts his hands on his knees, head now parallel with the concrete. When Seth bends over in disbelief, all you can see are his black hat and his tattoo that says: "Hard work."

Years later, I met Seth in person backstage at the Richard Rodgers theater, only this time he was dancing in *Hamilton*. I remember his open-faced kindness as he opened the backstage door for me, how pleased he was to show me where he worked. But what I remember most is sitting a few rows from the stage in the red plush seats, watching Seth do a dance move where he grabbed a lamp post and leaped around it, perpendicular to the spinning stage; for a brief moment, it was as if he really could fly.

Chapter 3:

BELIEVING
(AND NOT BELIEVING)

How to believe when others don't.

✴ CHANGING YOUR DREAM
(KRISTEN ANDERSON-LOPEZ)

When Kristen Anderson-Lopez was a girl, she wrote, directed, and starred in plays in her backyard, but most people didn't comment on her writing or directing.

"Over the years," she says, "I got the message, 'She likes theater so she has to be an actress.' Nobody thought of me as a writer or director because there weren't a lot of models to pull from then."

So, Kristen pursued acting in college.

Once she graduated, she went on auditions and started booking jobs, sometimes the same type of role, and quite a few in New Hampshire.

"Over the years I ended up playing several nuns in New Hampshire," she laughs.

But something felt off.

"I had this moment," she says, "where I felt like I wasn't using my brain; I didn't feel in alignment with my purpose." It's not that Kristen didn't think actors used their brains—far from it—she just felt like her brain wasn't an acting brain. *Her* brain, *her* superpowers, felt dormant.

She could sense that acting wasn't *it*.

She kept going because up to that point, acting was all she knew. But during one show, while working on a

cabaret, Kristen helped rewrite several well-known lyrics to fit the theme of the night.

After watching her work, the music director for that show turned to her and said, "You're a lyricist."

She asked him what she should do with that information, and he told her about the BMI Workshop, a premiere musical theater training program in New York City that he'd also attended.

She knew acting wasn't *it*, but maybe this was?

She applied and got into the BMI Workshop. For their first assignment, they were asked to write and present a song about "a sad hello or a happy goodbye." What Kristen wrote and presented was her very first full song. And when she shared it, everything changed.

"It felt so unbelievable to put words to music," she says, "to tell a story and connect to an audience. It was like the sky opened up and I was like, *Ah, now I'm in alignment with what I love.*"

That feeling became a dream. "I started to form the goal of, *I want to do this. I want to be somebody who tells stories from my own experience that connect with other people. I want to get paid to do this.* The idea of being able to do something that you love and get compensation for it was my first dream," Kristen says. "And that created little micro-dreams along the way."

She focused on the micro-dreams, but a *big* dream lay in secret, too.

"Somewhere very deeply in my soul I was like, *I want to do this on Broadway like my heroes,*" she shares. "I would joke about it in a secret kind of way, like, 'When I'm on Broadway . . . haha.' But it was really the goals that felt tangible that were far more useful for my own persistence."

Kristen kept her secret dreams tucked away and focused her attention on the smaller goals right in front of her, like, "I want to finish this song by Friday."

With that mindset, and years and years of writing and weeks and weeks of finishing songs by Friday, Kristen began to build a songwriting career, getting hired for projects like *Winnie the Pooh* and *Finding Nemo—The Musical.* Then, along with her husband, Robert Lopez, (they had met at the BMI Workshop), she was hired by Disney to write the songs for one of the first animated musicals Disney had produced in a while—*Frozen.*

Kristen and Robert won an Oscar for the film's title song, "Let It Go," and they have won many awards since. Kristen's lyrics also made their Broadway debut in the show *In Transit*, and she was nominated for a Tony Award for *Frozen,* the musical.

I saw *Frozen,* the musical, when it came to my hometown at the Dr. Phillips Center for the Performing Arts, years after interviewing Kristen. I wept when Elsa sang "Dangerous to Dream."

Today, in addition to hearing Kristen's lyrics sung in films and Broadway shows she's written for, you can hear them multiple times a day, *every day*, throughout Disney parks as part of the *Frozen* and *Finding Nemo* stage shows, *Fantasmic!*, and the current Magic Kingdom fireworks show. Millions have sung along to and enjoyed her words.

She says it felt incredible to see her big, secret Broadway dream come true, but that the real dream come true for her is getting to make art every day, for a living.

She says, "It's like pretending when you were a kid."

✷ GETTING SOMEONE ELSE TO BELIEVE
(D'WAYNE EDWARDS)

D'Wayne Edwards was always drawing athletes, especially their shoes. The youngest of six kids, raised by a single mother, he was often inspired by his siblings, especially his brother Michael, whom D'Wayne says "was a much better artist than me." Michael taught him and encouraged him.

When the Lakers came to D'Wayne's high school in Inglewood, California, to practice, D'Wayne got to meet some of the athletes. He asked them to sign his shoes, and then he asked about *their* shoes. Seeing them in person intensified his love of drawing shoes and sparked a dream: What if he could design shoes for a living—shoes like the ones his heroes wore?

Michael had the same dream too. But when D'Wayne was sixteen, Michael died tragically in a car accident.

It shattered D'Wayne. Then it shaped him.

"It made me realize that life is really short," he says, "and I realized I needed to get myself together and not waste the talent I had, to make an effort to have the career he would never have a chance to have."

D'Wayne practiced drawing even more after Michael died, often drawing six hours a day, every day.

"All through my senior year of high school," he shares, "all I did was draw."

During his senior year, he entered a design competition for Reebok; it was the first time he had shown his designs to someone outside of his friends and family.

He won that competition.

And when Reebok invited him to their offices to congratulate him on winning, he knew designing shoes was truly, absolutely, what he wanted to do with his life.

He asked someone at Reebok how he could get a job there. They said he was a little too young right then, but that he should come back and see them after he graduated from college.

So D'Wayne started researching where he could go to college and learn how to design footwear.

But he couldn't find anything.

He asked for help at his high school, but his guidance counselor dissuaded him.

"She'd never heard of anyone being a footwear designer," he says, "and she told me to join the military because she said no Black kid from Inglewood would ever become a footwear designer."

He also learned from Reebok that he'd need a portfolio, but at the time he had no idea what that was, nor did his guidance counselor, or anyone else. And, as it was 1988, he couldn't look it up online. D'Wayne graduated from high school that year, the same year the Air Jordan 2 was released, and the Air Jordan 2 was the last shoe D'Wayne drew for a while.

Since he was the youngest of six kids to a single mother, "there wasn't money to send me to college

anyway," he says. "So I kind of gave up on the idea of being a footwear designer."

After high school, D'Wayne continued working his fast-food job and got a second job as a file clerk with a temp agency, where he eventually got assigned to file papers in the accounting department for the footwear company LA Gear.

At the LA Gear offices, D'Wayne noticed a little wooden box. It was a suggestion box for employee feedback.

"Every morning," D'Wayne shares, "before I would start filing papers, I would put a sketch in the suggestion box."

It was something he did because of his mom, who gave him a card once that reminded him he needed to believe in himself before anyone else could. He put a new drawing in the suggestion box every day for six months.

Until one day a voice came over the loudspeaker in the offices: "D'Wayne, come to the president's office."

D'Wayne was terrified.

He walked into the president's office and saw all of his sketches spread out on his desk.

The president asked D'Wayne if he was the one putting all those sketches in the box.

"Yes," D'Wayne answered.

The president replied, "I like what you can do, and I believe in what you can do. You're hungry. I want to bring you in as an entry-level footwear designer, if you're interested."

D'Wayne took the job and made it his own kind of design school, learning from everyone he worked with, always asking questions and constantly practicing. (He also started attending community college classes at night.)

Within three years, he was promoted to a senior designer position. Years later, he got a job at Nike, where the first project he was asked to work on was redesigning the Air Jordan 2, the last shoe he thought he'd ever draw when he gave up his dream in high school.

In 2010, D'Wayne started the PENSOLE Footwear Design Academy to teach aspiring designers and create the educational environment he couldn't quite find when he was younger.

He still has the card his mom gave him about believing in yourself, and in the early days of PENSOLE he made copies of that card and gave one to each of his students.

"They're at that stage where there's going to be doubt, there's going to be people who are not going to believe in them," he says. "But at the end of the day, we shouldn't be worried about another person. You should be focused on being the best *you* you can be. And if you can do that, if your best isn't good enough yet, at least you can continue to work on getting better."

✳ ASKING FOR HELP NOT PERMISSION
(PATRICK DOWD)

It happened on a train in India.

Patrick Dowd was there as a US Fulbright Scholar, the only American on a train journey called the Jagriti Yatra, an innovative program that takes entrepreneurial young people in India on fifteen-day trips around the country to meet with entrepreneurs and brainstorm innovative solutions for some of the country's most urgent problems.

"Travel is one of the most surefire ways to expand the set of opportunities that are available to you," Patrick says, "and it can broaden your perspective." Travel also increases, he thinks, "the probability that something good and random is going to happen to you."

Patrick was so inspired by the Jagriti Yatra that he came back to the United States with a new dream; he wanted to create the same train experience he'd just had for young people in the United States. He wanted to start a nonprofit that would take diverse groups of millennial innovators around America by train; on the journey, they'd meet with leaders across the country and generate solutions to the pressing problems that moved them.

He wanted to provide an opportunity for young people to get out of their everyday context and take

their dreams to the next level, learning more about their own country along the way.

"The more you interact with different people and see new things," he says, "the more likely it is that you're going have a new idea or develop an insight that will lead to inspiration to do something new."

He wanted to create that experience for others. He also wanted to find a way to fund it because he knew many people couldn't afford the expense of travel. Patrick *really* believed in this dream, so much so that he quit his job before it was even off the ground.

His finance job in Manhattan had required eighteen-hour days, which didn't leave him any time to dedicate to this side project. He knew without a doubt that he wanted to start this new organization, and he wanted to give it his all. To stay financially afloat during the building stage, he moved in with his parents, a privilege he knows not everyone has.

"There were times I had, like, zero dollars," he remembers, "and my parents would give me $500 so I could go another two weeks or something."

He was grateful. But he knew he couldn't live like that forever.

He told everyone he could about his idea, especially people he thought might help, often opening the conversation with something like, "You know, I'm thinking about doing this thing with millennials and trains . . ." But one of his friends stopped him and gave him some advice, saying, "You need to start talking differently about what you're doing. Instead, say, 'I am leading the Millennial Trains Project; I am the founder.'"

She encouraged him to own it and declare it, even though it didn't exist yet.

It was really hard at first, he says. "When I first started trying to speak differently about it, it felt like I had a speech impediment. It was really hard to get it out, to say I was leading this thing which at that point was entirely imaginary."

But he tried, however awkwardly, to see if it made a difference.

And it *did*.

People were even more eager to help and offer support when he talked about his idea with more confidence. "You really do have to have faith in your own ideas to inspire faith in other people," he learned.

He wasn't *that* confident to begin with, but he learned that putting in the work even when he felt uncertain helped him prove to himself that this really was a good idea, which helped his own faith grow.

"If you earn your own belief, it's contagious," he says. "Whereas if you're like 'I'm thinking about this, I'm trying to find a way to do this,' that's not super inspiring."

Once he started taking himself seriously, everyone else started taking him seriously too. Once he really owned his dream and started acting on it, his belief and vision became contagious and others wanted to be a part of it. People love to get involved with someone who's passionate, full of faith, and already taking action.

Not everyone was interested, of course, but anytime someone was, Patrick asked for follow-up meetings. And in those meetings, he'd ask if they knew anyone *else* who might want to get involved too.

And while getting help from others was integral to starting his dream, Patrick was careful to remember he was only looking for help, *not* validation. He'd learned that lesson before, the hard way.

Back in India when he was doing his Fulbright research, he brought his idea for an electronic waste recycling app to a research center director to ask for help and advice before he entered his idea in a green mobile app competition.

The director responded, "This is never going to work; this idea you have is beyond impossible."

Crushed, Patrick put the idea away and didn't enter the competition. He left India, put his dreams away, and got a job in finance. A few months later, he learned that the winner of the green mobile app competition was another electronic waste recycling app, created by someone else.

"I was so mad," he remembers. "If I had just stuck with my own good idea, I would have been a real contender for this thing I really wanted, but I let this guy with all these credentials and seniority talk me out of it."

Filled with regret, he was determined to never ever let someone else, no matter their position or clout, talk him out of something he truly believed in.

So while Patrick constantly talked about his dream for the Millennial Trains Project and sought advice, he was deliberate in his purpose. He was looking for support and guidance, *not* validation.

"I'm not asking for anyone's approval," he says, "because the last time I did that I missed out on a great opportunity. I did not ask anybody, 'Do you think this is a good idea or not?' Instead, I approached those meetings with the confidence of, 'I know this is a good idea, I'm

gonna make this happen, and can you offer me some guidance? Do you want to be a part of this? Can you help?'

"Seeking validation from people can really get you to stall out," he says, "because not everyone is going to tell you that what you are doing is great, and if you need people to tell you that, you probably won't get your idea off the ground. You have to be willing to stand up for your dream when people poke holes in it, which they do all the time."

He allowed feedback, but he didn't take all of it.

"Your dream doesn't need to make sense to everyone in order to happen," he says. "You may only need one or two people to get behind your idea, and there's a good chance you don't know who those people are yet."

Once Patrick was able to say his dream out loud and take himself seriously, he started finding more people who were willing to help. He went to dozens of meetings, and during one lunch, the man across from him said, "Well, this sounds like a great idea, and I'd like to help you get off the ground. I'd like to support you financially."

"How much are you talking about?" Patrick asked, thinking a few thousand would be a game changer.

"Well, how about $50,000?"

Patrick felt like the wind had been knocked out of him. He couldn't believe it.

That money helped a lot, and eventually, after he got his first full grant, he was able to hire people to help, establish the 501(c)(3) for the nonprofit, and start a website.

But even with all that progress, there were still times when Patrick's belief wavered, such as when one of their sponsors backed out at the last minute and started their *own* train project.

Every step of the way, Patrick knew his dream could fail, which was terrifying. But deep down he knew the only true failure would be walking away too soon, like he had done with his app.

"Just hold on," he says, "and then at least you have the *chance* of it working out."

In 2012, twenty thousand young people applied for forty spots on the Millennial Trains Project inaugural trip. The night before the first train left San Francisco for its multiday journey across the United States, Patrick couldn't sleep. He was too excited.

Morning came and the train departed from San Francisco with Patrick and the forty people who were about to embark on this unique journey he'd dreamed up.

When it was time for dinner, the train crossed the desert in the Sierra Nevadas. Patrick's job was to hold the large container of pea soup so it didn't fall off the table as the train moved. He did his best to keep it steady as each person came up to get their dinner.

"That's when I realized," he says, "that we did it."

After that first trip his belief grew even more, and he didn't stop talking about his dream to everyone he could, everywhere he went, which led to the Millennial Trains Project gaining even more partners and sponsors, such as the Rockefeller Foundation, Comcast NBCUniversal, the US Department of State, IDEO, City Year, and National Geographic. But his dream-come-true moment, he says, will always be that time he served pea soup across the Sierra Nevadas.

✳ BELIEVING YOUR WORTH
(ESTELLA PYFROM)

Estella Pyfrom grew up in Belle Glade, Florida, where, she says, everyone looked out for each other.

"Living in the projects," she shares, "you realize how true it is that it takes a village to raise a child. We learned how to cook and clean and how to work together as a family, as a community. The older kids had to take care of the younger because our parents could not afford to pay for childcare."

And the parents were always working.

But that community sparked her dream, one that came to her later in life, after she retired from teaching. Estella's dream was to bring technology to kids in lower-income neighborhoods, to kids whose parents couldn't afford computers. And she wanted the technology to be able to travel, to meet kids wherever they were, in neighborhoods outside her own.

What about something mobile? she wondered. What if she put a technology education center on a *bus*, where kids could come on board to access and learn about computers?

As a Black woman growing up in the segregated South, Estella had been forced to ride in the back of every

bus. She says her positive sense of self-worth managed to survive because of her faith and community, despite the oppression and injustice she faced. Despite the messages she received from the outside world, inside, she says, "I knew I was loved."

And as a teacher and a mom she'd always tried to make sure as many people as possible felt that kind of love too, the kind that preserves faith and hope even during the unimaginable.

And for Estella, that kind of love and faith also expanded into what she believed she, and others, were capable of.

"If you set your mind to do something," she believes, "it doesn't really matter what the odds are. If it's something you really want to do, you can do it."

After she retired, she shopped for a bus to help build her next dream.

She wanted one she could drive but also one that was big enough to fit *a lot* of computer stations. She searched for weeks but found nothing. It seemed the kind of bus she was dreaming of didn't exist.

But Estella thought about something her dad always used to say: "Look past what your life is today, to the life in the future." And to him, that was a future you could always have a hand in making. So with paper and pencil, Estella sketched out her dream bus, the one that didn't exist, and then she found someone across the country, in Henderson, Nevada, who made custom buses. She packed up her sketch and drove to Nevada.

The designer said he could make what she wanted. But there was one problem—it was *very* expensive to build a custom bus.

But Estella believed in this dream so strongly that she decided to invest the money she'd saved for retirement into building the bus. She could always go back to work if she had to, she reasoned. But she was also really confident.

"I was 150 percent sure that I could make the concept work," she says. "All I needed was the bus."

She built her dream bus.

But, before she could take it out for a drive, her husband had a major health scare that would require an intensive recovery.

Her dream bus sat dormant while she helped her husband through his recovery.

But when he was well again, she drove her bus for the first time, parking in neighborhoods around Florida and teaching kids about technology.

Every kid that walked onto the bus would first see the mirror Estella had installed. Every time a kid walked on she asked them to look into the mirror and say, "When I look in the mirror what do I see? A brilliant mind looking back at me."

She named her project "The Brilliant Bus."

Estella spent months living her dream, driving the bus, teaching kids about computers and their worth. But one day, when she and her husband were driving to the garage where they parked the bus, a car ran a red light and sped right into them. Their car was totaled, leaving Estella with a broken hip and her husband with a broken neck; his spinal cord was injured, paralyzing 95 percent of his body.

The bus, it seemed, would be a short-lived dream.

Except by then, Estella's dream had spread. When people in her community heard about the accident, they stepped in to help her dream continue.

"People who believed in the project, this mission, came to our rescue," Estella says. "They carried me where I needed to go because I couldn't drive; they came to our home to take care of both of us every day. It was just beautiful.

"We always hear 'Work hard and you'll be successful,' but that isn't the whole story. It's not just *you* working hard. You need the support of others."

Estella and her husband were eventually able to walk and drive again. And with the help of the community inspired by Estella's dream, her Brilliant Bus has served over 300,000 children to date. It continues on to this day, even though Estella herself passed away in 2021.

And while Estella created her bus for those kids, not for recognition, her dream did catch the attention of CNN, NBC, and even Oprah. I learned about Estella when I saw her in a Super Bowl commercial.

But Estella told me her dream come true wasn't any of that; it was knowing that she (and others) could go "from standing in the back of the bus to owning the bus."

Part 2:

the growth

*"We want the spark but
we don't want the burn."*

—Drew Holcomb, from the song
"You Want What You Can't Have"

Chapter 4:

MENTORS

Dreams don't come true without help.

✴ FINDING DREAM MENTORS
(SCOTT BARRY KAUFMAN)

Growing up, Scott Barry Kaufman had a lot of ear infections, and they affected his ability to focus. In elementary school, Scott was labeled as having a learning disability and put in special education.

He was devastated and always felt like he was capable of more. He tried to explain to his teachers that he could do more, but no one seemed to believe him—until ninth grade, when his special education teacher took him aside and asked him why he was still in special education. He didn't know how to answer; at that point even he'd grown resigned, adopting the perceptions of others, believing what they believed, seeing himself only through their eyes.

"I had very low self-esteem," he remembers. "She really did empower me. If someone else was questioning it, why can't I question it? What really gave me confidence was when I started to see that I actually *was* capable of more than I realized. Like, why did I listen to all these idiots all these years, you know? I realized it's time to listen to myself."

This teacher's fresh eyes and quiet belief inspired him to advocate for himself by asking to be moved to general education classes.

"She inspired me to push my limits and see what I was truly capable of achieving," he says. "I never would have realized until someone told me to question my place in the hierarchy of the school system."

Scott was moved into general education classes where he thrived. By his junior year, he asked his guidance counselor if he could be in gifted classes.

His guidance counselor checked his IQ test results (a test he took when he was eleven years old) and said sorry, he didn't qualify for gifted education (even though he was getting straight As in all of his classes). There was no need to test him again; according to her, "intelligence doesn't change."

Scott thought she was wrong. And his dream became to prove it—not so much for himself or his own ego, but for the chance to make an impact on the very definition psychologists and schools used to assess intelligence so that he might empower others the way that one teacher had empowered him.

And most of all, he was tired of being defined by everybody else's metrics; he wanted to choose his own.

When Scott was ten years old, he had filled out a worksheet that asked, "What do you want to be when you grow up?" He'd written, "Academic psychologist."

His parents found the old worksheet recently, and he guesses he knew about that job because of all of the psychologists he was brought to as a kid. The worksheet itself was from one of his psychological evaluations, and Scott remembers what the psychologist thought of his dream: "He told my parents I had delusions of grandeur."

But by high school, Scott was done listening to what everyone else said he was or wasn't capable of.

After he was told he didn't qualify for gifted education, he was determined to formally investigate the nature of human intelligence. He started in the school library, where he found a book on IQ. He read about all the "expectations" one should have of someone with each IQ score, and he looked up what it said about the score he got when he was eleven years old.

The book said he was unlikely to graduate from high school.

Except he *was* on track to graduate, with straight As.

Scott threw the book down, his determination growing. He would prove this book wrong. He would prove that psychologist wrong. He would graduate from high school. He would go to college. He would redefine intelligence so no one else would have their potential limited.

But "redefine intelligence" was a vague, relatively *big,* and almost intangible dream. Where would he even begin?

He started with college. He graduated from high school and was accepted to Carnegie Mellon University, where he avidly soaked up everything he could learn about psychology and intelligence. During a cognitive psychology class, he was assigned a textbook that had a whole chapter on intelligence, and the author's take was the *opposite* of what Scott had read in that IQ book that day in the library. He immediately looked up the author, Robert Sternberg, a professor at Yale University. He felt what he describes as an unexplainable sense of, "This is my path." He knew he needed to work with and learn from Robert Sternberg.

That day, Scott approached his professor, Anne Fay, showed her the textbook, and said, "This is my dream. I want to go to Yale. I want to study with Robert

Sternberg. Will you help me?"

"I actually know Robert Sternberg," she replied. "I worked with him on a project once. I'll email him and tell him about you."

Then, impressed by Scott's dedication and his dream, she asked if he would like to do an independent study with her on intelligence. He said yes.

Scott graduated with a bachelor's degree from Carnegie Mellon, then a master's degree from Cambridge University, and then his PhD from Yale, where he studied under Robert Sternberg.

In 2013, Scott's first book was published. It's called *Ungifted: Intelligence Redefined*.

✳ WHAT MENTORS CAN SEE
(AMY ELIZABETH SOTO-SHED)

When Amy Elizabeth Soto-Shed was in elementary school, she heard Harvard was the best university in the world and she dreamed of going there.

"But it was one of those things I knew would never happen," she says. "Kind of like, *Oh, one day I want to be famous.* That's how I saw Harvard."

After high school, she attended a state school, then law school. But law school didn't work out, so she left and instead worked a variety of administrative support roles. In 2008, she applied to Harvard, for a job. She was offered a temporary faculty assistant role that would only last for three weeks. She almost didn't take it, but her mom encouraged her, saying it could be a step toward getting hired more permanently. And it was. Amy got a full-time job at Harvard's law school.

She was content, and thought, *Maybe being an administrative assistant is what I'm meant to do.*

But her new boss thought differently; she pulled Amy into her office one day and said, "What are you doing with your life?"

Amy was confounded—and defensive. "Hey, I've got a great job. I'm living in Boston. I have a great life."

But her boss saw more for her, because she saw more *in* her.

"You should apply for graduate school," her boss said, explaining to Amy that her job included a tuition assistance program that would help pay for graduate school.

"I did really badly in my undergraduate, and I remember looking at her thinking, *I'm not going to get in anywhere,*" Amy remembers. "I left her office thinking she was crazy. There was no way I was going to get my master's."

She ignored the advice.

But then *another* colleague approached her one day and said, "You know, there's a master's of higher education program at Harvard. You're really good at what you do—you should look into it."

"Again," Amy remembers, "I looked at him like, *You're crazy. I'm not going to get in.*"

Amy's past was louder than their encouragement. But they didn't stop.

"They kept pushing me," she says.

Eventually, their voices crowded out her self-doubt, and she decided to go ahead and apply to graduate school at the Harvard Graduate School of Education and at Suffolk University, the latter because she still didn't believe she'd get in to Harvard.

She was right. She didn't get into Harvard. But she did get into Suffolk, where she started graduate school and promptly fell in love. With school.

"Graduate school truly opened my eyes," she says. "I was an immature student back in undergrad. This time I was getting As, and I worked so hard for those As."

She still worked at the law school while going to graduate school, and her boss often asked how things were going. Once, Amy excitedly mentioned an A she got on a paper and another A she got on a group project, and she did not expect what her boss said next.

"Oh, that's great," her boss replied. "That's going to help your portfolio when you re-apply to Harvard."

"You know," Amy replied, "I'm very content here at Suffolk."

Amy was mad at her boss for replanting seeds of a dream she'd already given up on. *I wish she didn't have this dream for me*, she'd think. Because she didn't want to deal with the rejection *again*. It hurt too much.

But her boss and colleagues kept telling her they believed she could get into Harvard if she tried again.

Finally, mostly just to get them to stop, she applied again, all the while thinking, *I'm not going to get into Harvard*. She didn't *believe*, but secretly, their encouragement did make her *wonder*. What if they were right?

Because deep *deep* down, she still wanted to go to Harvard; the dream was still there.

"I *truly* didn't believe I could do it," she says. "But I did want it so bad. I almost was fighting against myself, like I was cut in half. There was the half that said, *Amy, you suck at this. Stop. Accept your life for what it is. You're not an academic.* And there was this other half that was like, *Girl, you're an academic, you just need to shut the TV off, turn your phone off, and put your head in the books.*"

The encouragement she received from her boss gave the latter voice a little more power, and Amy got into Harvard this time.

When Amy began her graduate program at Harvard, she was ten years older than many of the students, and many of them looked to her for help when they were stressed and doubting themselves.

"You were picked to be here," she'd tell them. "Someone read your application and decided you needed to be in this program, so you belong here at Harvard. It was not a mistake. You're smart enough. You can do this." And somewhere along the way, she finally started to believe this about herself too.

"If someone told me ten years ago, 'You will be a master's student at Harvard University,' I wouldn't have believed it," she says. "And it's not that I didn't believe in myself exactly, it's just that it didn't even occur to me to think I could really do something like that. But because of mentors, something so untouchable is now in my hand. And now, I see in me what they saw."

✱ ASKING (AND ASKING) FOR HELP
(MATEO*)

When Mateo was young, social services took him away from an abusive stepmother and placed him with a foster family. That family lived in a nice school district, and there, Mateo learned about college. He dreamed of going one day.

Eventually, once his stepmother was out of the house, he was able to live with his father. From then on Mateo put all his energy into getting good grades in high school so he could go to college. He started applying to schools as soon as applications opened during his junior year; every application required his Social Security number, so he asked his dad what it was.

"And he told me," Mateo remembers, "that I didn't have one."

That was the day Mateo learned he was undocumented.

In 1993, Mateo's dad had fled Mexico to escape the drug cartels that were rampant where they lived. His dad was a farmer who hoped coming to the United States would give his two young sons a fighting chance at survival.

Mateo's dad had married again and they had kids, so when stories were shared about Mateo's siblings being

born at a hospital in Washington, Mateo just always assumed that's where he'd been born too.

But it wasn't.

And then, shortly after Mateo learned about his undocumented status, his father was deported to Mexico. Mateo was left alone to raise his six siblings while finishing high school.

His dad had a tree farming business in Washington then, growing curly willow trees people bought for weddings. Mateo kept the business going while his dad was gone, delivering branches whenever he could.

While Mateo's college dreams felt more impossible than ever, he still couldn't help but dream.

"I thought education was our way out of the whole mess," he says. But since he had no idea how to make that happen, he decided to ask for help from people in his school.

At first, most people told him how impossible his dream really was.

"I would just ignore them," he says, "and ask someone else."

Eventually, he found counselors at his high school who saw his potential and wanted to help, especially when he opened up and told his full story.

"Stories are so powerful," he says.

The counselors researched and told him that the local community college would accept him as long as he had a high school diploma he could show.

He was disappointed at the thought of attending a community college at first because he'd always dreamed of going to a four-year college. But this seemed like his chance, so he decided to make the most of it.

In community college, he joined the student government, which also helped him pay for school. It was there that he found students and staff he trusted enough to share his story and his dream of transferring to a four-year university after graduating from community college.

Wanting to help, the student government did a fundraiser so they could hire an attorney for Mateo, one who could help him get the citizenship status he needed to transfer.

"They did a campaign in a matter of days," Mateo remembers, "and then hired the best family immigration attorney they could."

That lawyer told him that because of his early days in foster care, Mateo could qualify for a special kind of visa available to those who have been victims of a crime in the United States. After three years with that visa, he would be able to apply for a green card.

The lawyer was able to get him that visa, and Mateo transferred to a four-year university, where he graduated with a BA in criminology.

But what he remembers most about his graduation is the look in his siblings' eyes: "Now they know what's possible."

Name and some details changed for privacy.

✴ CONTACTING YOUR DREAM MENTORS
(DAVE ELSEY)

Dave Elsey never missed the Saturday night double bill of monster movies.

"I was just fascinated by monsters and creatures and that actors could make themselves look so different," he says, "and I really wanted to be able to do that."

He dreamed of being a makeup artist one day.

"I would experiment on myself and try to do build-ups with Plasticine on my face," he says of his early days playing as a kid.

One day his grandfather, seeing how much Dave loved monster makeup, uncrinkled a center spread in the newspaper about "the guys who made the monsters" and gave it to Dave.

Reading that torn-out piece of paper, which featured a story about someone who did monster makeup for a living, Dave realized for the first time that the thing he loved could be a job. He started researching everything he could in libraries and bookstores about how someone could do monster makeup for a living. He studied the art and the artists who came before him, looking for a path.

He didn't have the internet then, but he did have a magnifying glass. Whenever he found photos of a

makeup artist or their work, he'd use a magnifying glass to study everything up close, especially when the photos featured the artist's workshops. Dave would slowly scan, looking for clues to what supplies they used, how they did what they did; he even tried to make out the titles of any books they had on their shelves.

He used his small allowance to buy whatever supplies he learned about and kept experimenting. And because he was the only kid who went to the professional art store, the owners got to know him and eventually helped him do more with his small allowance.

"Look," they said, "we just got this new stuff in and we don't really know what it does. Why don't you take it home and play with it? Then you can come back in and tell us what it does—and you can have it for free."

Dave loved this and made a follow-up offer, asking, "What if I make stuff for you, like rubber noses or false teeth, and you pay me with materials?" They agreed. "That was basically the first paid makeup job I ever had," he says.

When he wasn't making, he was reading. He started seeing one name over and over again: Rick Baker, a young makeup artist who'd already done work for films like *King Kong* and *Star Wars*.

One day Dave saw in a magazine that Rick Baker was going to be working on a movie at Elstree Studios in London, near where Dave lived. So, when Dave was fifteen years old, he called the studio to ask for their mailing address and wrote Rick Baker a letter.

"I wrote to him that I was a big fan of his work," Dave says, "that I had seen *King Kong*, and that it made me want to create stuff."

Dave didn't really expect a response from Rick, but he just wanted to reach out to one of his heroes, someone who loved what he loved. So Dave was surprised when he received a two-page letter back from Rick. Rick gave Dave his phone number and asked him to call. Dave was terrified but called anyway, and Rick invited him to the studio for a tour.

Dave took the day off from school and went to Elstree Studios to meet Rick, where, for the entire day, Rick showed Dave everything about the makeup work he was doing for the film he was working on at that time.

"It blew my mind," Dave remembers.

But it also discouraged him a little. Seeing his dream so close and how the makeup for the film compared to what he was making at home showed him how far he still had to go. But what kept him from spiraling was that Rick gave him something to do.

"He gave me a bunch of masks to take home and said, 'Practice sculpting them over and over again.'"

That day at the studio with Rick, Dave says, "completely altered the course of my life."

Dave spent the next three years doing what Rick advised, spending every day after school sculpting those masks over and over again, often working until midnight. He spent most of his weekends practicing as well.

When his aunt and uncle saw his passion, they offered him their spare room so he could have his own studio.

Sometimes, he wouldn't even go home, sleeping at his aunt and uncle's house so that he could practice what he called "night standing": he'd prop up the latest mask he was working on next to his bed right before he went to sleep so that when he woke up it would be the first

thing he saw. If he woke up and it didn't "look cool," he'd know he needed to keep working on it.

"You know how people talk about having monsters under the bed?" he says with a laugh. "I had monsters by the bed."

But despite his dedication, when he got older and it came time for him to look for a makeup job in the industry, he couldn't get one.

"Basically," Dave explains, "you had to have worked on a movie to get into the union, but you couldn't work on a movie unless you were in the union."

However, he kept trying. He found out there was a newer field—animatronics—that would hire non-union workers, so Dave took a job in the animatronics department on a film—a horror comedy musical called *Little Shop of Horrors*.

Dave loved what he learned on set, but his new job created a new problem. "People thought I was an animatronics guy now," he says. Now he was in the union because of his *Little Shop of Horrors* job, but he still wasn't able to get anyone to hire him to work as a makeup artist.

Years went by, and people started telling him that maybe he needed to give up on this dream and think about doing something else. But Dave wasn't ready to give up before he'd even had the chance to start. He wanted to at least *try* being a professional makeup artist.

But still, no one would hire him. So that's when he decided to hire himself.

"I thought, *I'll set up my own company, and then I'll be the one who lets me do what I want to do*," he says. "Then I'd be the one who says, 'Dave, why don't

you be a makeup artist? Why, thank you very much, Dave, I will.'"

He was excited. But also, he remembers, "I had no money and it was terrifying."

He started small, getting clients with limited budgets. But they *raved* about Dave's work; all of those years Dave spent creating on an allowance budget meant he'd learned how to do quality work with very little money. His work was *much* more realistic than people were used to seeing on low-budget projects. Once he became known for that quality, people started referring him and even seeking him out.

Like George Lucas, who called Dave one day to ask if he'd work on *Star Wars*.

Dave said yes, and for years he continued to do the work he'd been doing since he was a kid. And in 2010, he won an Oscar for his work on *The Wolfman*, a project he did alongside a mentor turned colleague: Rick Baker.

Chapter 5:

THE PROCESS

Practice makes progress.

★ TALENT VS. PRACTICE
(JUSTIN DAVIS)

Justin Davis says his dream was the same dream all of his friends had growing up: "To be the next Magic Johnson." By the time Justin was seven years old, his *only* dream was to play in the NBA. It seemed like a sure path to him then.

"You play in college, then professionally, then you get shoe deals, then you're in commercials, then you're famous, then you buy your mom a house," he says, reciting the clear path he and his friends saw from afar.

He practiced on his Nerf hoop constantly, and when that wore out, his dad put a small hoop up in their backyard. Then, when his dad saw just how dedicated Justin was, he poured concrete in their backyard and set up a ten-foot hoop.

Justin truly *loved* playing; when he wasn't playing with friends at home he would travel from park to park to get in on any pickup games he could. In middle school, he joined a traveling league and loved putting on his first jersey. He remembers that time fondly.

"I didn't feel like I had anything to prove," he says. "I just enjoyed playing."

He had some natural talent, and that, coupled with his constant playing, got him far. But during his senior year of high school, something started to shift. He wasn't the best player anymore. He tried to figure out what had changed.

He studied the guys who were the best. They seemed a lot like him. They had some natural talent, they loved basketball, and they played constantly. Why had he suddenly fallen to the middle of the pack?

He noticed these other guys were hyper-focused on practicing the fundamental skills of the game versus just playing all the time. Justin realized he had to make a choice. If he wanted to progress as an athlete, he would have to start practicing the fundamentals. It was clear he'd come as far as he could on raw talent and love of the game. Now, for the first time, he needed to ask himself what basketball really meant to him. If he was really serious about playing professionally, he would need to put in even more time, *and* he was going to have to do a lot more of the "boring" stuff, the stuff not about playing, but about *improving*.

Was it worth it?

Honestly, he wasn't sure. He also thought it would be cool to be an architect instead. Maybe basketball could stay something he did for fun? There'd be nothing wrong with that.

But when he got recruited to play in college, he thought, *Why not?* He knew other jobs would always be there; this was the only time he could really try for this long-held childhood dream.

He dedicated the next four years to mastering the fundamentals, which, he says, required him to shift

his mindset from looking at basketball like a hobby to seeing it as a job.

He put in the work, knowing that there would still be no guarantee that basketball would ever actually become his job. But he figured, why not open up the possibility?

He couldn't control what happened next, so he focused on the only things he could control: practice and play, play and practice.

And after Justin's senior year, he entered into the NBA draft.

But he didn't get drafted by any of the teams.

He was devastated but not deterred. A team in Greece offered him a contract, and he jumped at the chance to keep playing and developing his talents.

A year later, he was offered an NBA contract with the Golden State Warriors and turned that into other opportunities to continue his basketball career.

His career was short-lived due to an injury, and to this day, he says when people find out he wasn't in the NBA for that long, they seem a little disappointed. But he isn't. He walks away from those conversations with a smile, thinking, *I had a locker. I had a jersey. I did it.* And seeing how far he could go in one area inspired him to keep going and dream again.

"I'm pretty proud of the person that I am right now," he says, "and I'm excited to see who I will become."

✳ HOW TO PRACTICE
(WAYNE TUCKER)

Growing up, Wayne Tucker was acutely aware that many people seemed to hate Sunday night; they spent it dreading the predictable slog that awaited them on Monday.

Why do something you don't like constantly? he wondered.

His dream, he decided then, was to live a life that wasn't predictable, one where he would never hate Sunday night, where he liked what he did every day.

He had no idea how to make that happen, but he wasn't in a hurry. He knew what he *didn't* want, and that felt like enough for now. He'd keep an eye open for what might spark him closer to a direction that interested him.

And soon enough it happened, during one of his private music lessons. Wayne grew up playing the trumpet, and he had noticed that his music tutor seemed to live life differently than all of the other adults around him.

"My private trumpet teacher played in the symphony orchestra in Syracuse," he says, "but during the day he just kind of chilled. I realized, *He just gets to play music and teach music all day. And he doesn't have to wake up early? That's awesome!*"

Wayne wanted to be just like him and decided to get serious about his craft. He loved playing the trumpet for fun but always considered it a hobby. *What if*, he wondered, *it could also be a path to the fun life I've always dreamed of?*

He knew from his music lessons that practice would be the best chance for him to get good enough to even have the chance at turning music into a job. So he practiced constantly, and indeed, by the end of high school, he was known as the best trumpet player in town.

Then he went to college for trumpet, where everyone was the best player in *their* town. "You go from being the best," Wayne says, "to nobody noticing you, just like that."

But Wayne also grew up playing sports and describes himself as competitive: "There was no way I was going to look at someone else and think, *Oh they're just better than me and that's what it is.*" Instead, his internal response was, *"They're great and that's true, and I just need to sit down and practice.* Because practicing," he says, "really builds your confidence."

Wayne approached all four years of college with that mindset. After he graduated he moved to New York City with hopes of breaking into the music scene. He worked odd jobs around the city, even selling things on the street. But after a year of that he decided to quit those jobs and go all in on music.

The odd jobs made him feel secure, helping him pay rent, but he wanted to see what would happen if he had to *fully* rely on music to pay his rent; it was an experiment of sorts. The odd jobs would always be there, so he figured it couldn't hurt to try. And he was curious to see if the added pressure would motivate him even more.

It did.

He learned quickly that the key to getting paid work as a musician, at least at that time in New York City, was to build relationships inside the music community.

"The more musicians you knew," he explains, "the more people would call you for a gig."

And he met those musicians by showing up to any informal jam sessions he'd hear about happening around the city.

"You have to show up to a lot of these to build that community," he says, "*and* you have to be, well, good."

Once he met other musicians and started to build trust, he'd get phone calls from fellow musicians who needed a trumpet player for a paying gig. Wayne said yes to every gig, and showed up as an audience member for his friends' gigs as well, just to support them.

As the community expanded and the gigs accumulated, so did more opportunities, including an offer to play in a club almost every night. A club manager simply approached Wayne once after a show and hired him for a regular gig that allowed him to pay his rent by working as a musician.

That's rare, which Wayne is all too aware of; he knows many great musicians who still need to have day jobs. He guesses that the reasons he was able to make a living as a musician so quickly was twofold. First, the fact was, there weren't many trumpet players around. Second, he was committed to his craft beyond just being good at his instrument—he also focused a lot of his practice time on being good at a *gig*, at learning how to make music that positively affected other people.

"There's people who know how to play their instruments well and there are people who know how to play

gigs well," Wayne explains. "I'm constantly observing things a lot of musicians don't see."

He's always reading the room, looking into people's eyes, noticing if he's adding to an atmosphere or taking away, if his music is creating an enjoyable experience for someone or not.

"We get to be selfish all day when we're practicing and composing," he says. "During the day you're selfish so that at night you can be selfless; you practice really hard during the day so that you can communicate something."

Once, after a gig, someone came up to him and said, "I came to see you play a couple years ago with a friend of mine who'd just gone through a breakup and was really sad. You played a song that you wrote, and it cheered my friend up. To this day when we get together, we sing your song."

Wayne thinks about that story every time he feels tired, especially during gigs when he's feeling tempted to phone it in and just get through it. Instead, he always gives his best because "you never know who's sitting there."

And he doesn't mean a potential manager or label head. He's not concerned with who in the audience might help *him*; he's more concerned with reaching the audience members *he* can help with his music.

His music dreams did grow, but he wasn't focused on rushing them. As a part of the music community, he was all too aware that being a talented musician didn't automatically mean success, and there certainly wasn't any guaranteed timeline for getting paying opportunities or "breaks."

"You don't get to choose the timeline or the way that it manifests itself," he says.

So instead, he focused on what he could control: meeting musicians, playing gigs, paying attention, and practicing, practicing, practicing.

"I'm someone who sleeps with a trumpet in my bed sometimes," he laughs, even though he's serious. "I don't even get out of bed sometimes; I just grab it and start playing thirty seconds after I wake up."

He does this because he enjoys it. "If you aim for something you love, even if you're a little bit off, it still might lead you to places even more fulfilling. But you have to enjoy the process. If you don't, then you're likely not going to put in the amount of hours you need to give yourself a chance."

So Wayne kept putting in the hours. Then one day, he caught a break. Music director David Cook needed a trumpet player. He asked a friend if he knew of any great trumpet players, and that friend recommended Wayne. David listened to Wayne's music and wanted to hire him, but before he could offer him the gig, one more person needed to approve Wayne's sound for the upcoming gig: Taylor Swift.

She approved, and Wayne played with her and other musicians for "Shake It Off" on the streets of New York City; the performance was broadcast on television by *Good Morning America*.

If you ask him about that experience, he won't brag about getting invited to Taylor Swift's birthday party that year; instead, he'll light up and tell you about everything he learned from that gig, like how to play with an entire horn section, how to play with earphones in the whole time, how to play for a national morning show, and (from working closely with David

Cook) what it takes to be great musical director for a major recording artist.

Today, Wayne is a music director himself, has his own albums, and even does private lessons, just like the teacher he had admired so much. No two days are alike, and he never has to wake up early.

Still, not everyone sees his dream coming true as a good thing.

Some people, he says, are still incredulous when they find out what he does for a living. "You play music?" they respond. "And what else do you do?"

But he doesn't need everyone to get it. Because for him it's enough to love Sunday nights.

✷ ENJOYING THE CREATIVE PROCESS
(DON HAHN)

Don Hahn dreamed of being creative for a living; he didn't know much more than that, but he learned early on how to identify the *feeling* of being creative, a feeling he wanted to follow.

He first felt it as a kid, putting on puppet shows in the garage for no one, and then again sitting under his comforter with a flashlight under a sieve, making "stars."

Don followed that feeling throughout his life. He played drums. He drew. After college, he got an entry-level job as an assistant to animators on the Disney Studios lot in Burbank.

"I felt like I'd won the lottery," he says.

He spent his days getting people coffee and running to the archives to retrieve old drawings the animators needed for reference. He may not have been creating himself, but being close to artists gave him that feeling. He learned everything he could from those he was working for.

And his attitude was noticed. He moved up again and again, always focusing on giving his best to whatever was in front of him, relishing the dream come true of being in a creative environment, no matter the task.

And then, when the studio wanted to adapt the old fairy tale *Beauty and the Beast* into an animated film, they asked Don to produce it.

Beauty and the Beast got a standing ovation at the New York Film Festival, was nominated for an Oscar, and won a Golden Globe Award. Don himself was the person who accepted the Golden Globe at the awards show and gave a speech on behalf of his whole team.

But none of those were Don's dream come true moments.

"I'm most proud of those days where we sat in a room until three in the morning trying to figure something out," he says. "Those are the better times, and I wouldn't trade any of that for red carpets or tuxedos. The real dream in my life was to be in the room when something was being created."

Don had mostly created alone as a kid, so creating alongside people who cared as much about creative magic as he did brought a new kind of joy. And that magic, he said, really came alive when everyone in the room honored how each other's personal experiences could contribute to the creative process.

"There's no ceremony where great ideas are handed down to me or anyone else," he says. "You just have to use your life."

And when your bucket runs empty, you can fill it up again.

"I think there's this myth that you are born with talent, that you have this taste coming out of the womb. I just don't think you do," he says. "The people I know who have that, they either got it from reading or from travel. All those people at Disney that I hung out with for

years were also architects, fighter pilots, fly fishermen. They had these big lives; they weren't just cartoonists.

"I think that my biggest fortune is that I am really curious. Some people are just that way, but you can force that curiosity in your life too.

"The fact that you are willing to get on a plane," he says, talking directly to me now as I sit across from him in his artist's studio in California, "call somebody like me that you don't know, and just show up is 98 percent of it."

I say thanks, but also share that the process of creating this book has often made me feel a little crazy: taking these kinds of chances, reaching out to strangers, doing something no one else I know is doing. His response terrifies and delights me.

"It *is* crazy. How cool is that? How many people would love or should have some crazy in their lives but don't? You can manufacture that with leaps of faith. To me, that's the dream. Going for it, you know? Having belief in something. And then keeping your eyes open and working harder than anybody else.

"That's the part that no one wants to hear. No one wants to hear the work part. How many writers in Los Angeles have a screenplay in their dresser drawer? It's not in the drawer because they are no good at writing. It's because they've stopped studying. The writers I know study.

"If you're a musician, you understand your scales. If you're an artist, you understand color relationships. That's like Dream 101. It's a part a lot of people miss.

"Some feel like, *Oh, I went to college.* Well, that's good, but that implies that your dreaming is done, that your knowledge is done when you graduate, like, *Phew*

I'm glad that's over. But the people I work with never stop learning. All of the artists I worked with worked their butts off into their nineties, because it's not about arriving. As good as they drew, they still went to art classes."

Don too kept learning, growing, and feeding his curiosity. He went on to produce many more films after *Beauty and the Beast*, such as *The Lion King*, *The Hunchback of Notre Dame*, and *The Emperor's New Groove*.

But that's not the end of the story.

Don was fulfilling his dream of being creative for a living, but what he didn't expect was the pressure that would come along with that, especially in Hollywood.

"*Alright*, I thought, *I'm a producer now. That means I need to drive a certain type of car and sit in the front row at Lakers' games.* But I failed miserably at all that stuff, because I just don't like it. It's not me. I struggled, and still do I suppose, to be my authentic self and accept that that's okay. Because the minute I try to be like somebody else, it doesn't work."

He tells me about the moment he and his team were stuck on one of the final scenes of *The Lion King*, when they felt like something was missing, and then they added the moment when Mufasa would materialize in the clouds to tell Simba, "Remember who you are."

Don loved his job. But after decades of making films, he started to feel burned out. He even felt depressed at times. Don decided to take a year-long sabbatical.

He tells me how relieved he felt when he stepped away—and then, how terrified. Because for the first time in his life the phone stopped ringing. For the first time since he was a kid, he was alone. It would be up to him to create whatever happened next.

For the first few weeks, he just sat around in his studio and remembered what it felt like to be bored. And boredom birthed curiosity.

Especially when a friend of his told Don that he was going to Romania to help with orphans there. Don was curious. Maybe he should film his friend? Make a documentary?

It was an impulse, a feeling, and he followed it all the way to Romania.

Don made that film, called *Hand Held*, and went on to start his own production company, Stone Circle Pictures, where he produced many more documentaries, including *Waking Sleeping Beauty*, *High Ground*, *Freedom Writers*, and *Howard*. After his sabbatical, he even went on to produce Disneynature documentaries and some live-action films.

But what the sabbatical reminded him of was that kid under his covers with the flashlight and the sieve. He remembered that feeling and remembered to keep following it, even if it went in new directions.

Around that time, Don also started painting, which taught him even more about the creative process. In his studio, he points up toward the ceiling to show me the paintings leaning atop a high ledge. They aren't for display, he says, but for fixing.

"Almost all of my paintings are rescue jobs. You start out with a vision of what you want but in reality you go, *That's awful. How can I rescue this?*" He puts them up high to get a new perspective and displays them so he can see them every day and hope to decipher what exactly needs fixing.

And when an idea doesn't come, he asks for help,

pointing out the paintings above when friends or family are in the studio, asking them to tell him what they see. His wife, Denise, also a painter, is one of his favorite critics. When you're stuck, he says, fresh eyes are everything.

"How do you handle the part of the creative process when criticism comes?" I ask. "Especially when you're in a vulnerable place?"

"It's hard," he admits. "You may always feel that personal reaction to it. What I've tried to do over the years is train myself that it's about the work, not about me. It's a painting, it's not me. It's a movie that's not working, not me. In fact, I'm the one who has the solution for how to make the movie work, so take it easy on me because I'm going to fix that."

I tell him how that reminds me of something I wrote in my phone notes app a few days ago: "You are not your dream."

"Exactly!" he responds, elated. "Like, 'You are not your soufflé.' Like, 'Oh my soufflé fell and it's flat and it's really bitter and I hate this.' That doesn't mean you are worthless. But people will feel that way. Like when somebody says, 'I hate your soufflé,' it's like they're saying, 'I hate you. You didn't do your job. You screwed up.' And that's a real thing. I think that's something all of us have to watch out for because it's self-defeating. Also, it's not you. Your dang soufflé fell.

"Or you did a bad painting. I have boxes of bad paintings. *Boxes*. I'm happy to show you."

Don's next dream, he tells me, is to show his (good) paintings in a gallery one day. Years after our interview, he does; I have many of his prints on my walls. Those paintings were also published in a book, and in that

book he also included some of the "bad" paintings in the boxes because he's grateful for where they got him.

"Sometimes I look at them and go, 'Ew,' but I know I wouldn't be doing the better paintings had I not done those. I wouldn't know how to make a soufflé and have it be brilliant had I not done a bunch of bad ones. And it's not that I was bad and now I'm good. That's the pit to fall into. You're perfectly fine the way you are.

"And if there's places you need to get better in terms of craft, great, get better in craft—take a class, go out and learn, work hard. But that's not about you, personally."

"What about when that growth process, or a creative project, takes a long time?" I ask him next, not knowing how much I would cling to what he was about to say, especially when my own project would go on to take many more years than I expected.

"The length of time it takes to get some things done is depressing. It just is. Really, nine years [to make a film]? Why does it take that long? It just does. It takes half that time just to convince people you're serious about doing it."

To get through that pain, Don prefers to have a lot of creative projects going at once.

"So if a certain thing isn't moving forward, fine, that just needs more time in the oven. Then I'm going to go over here and do this other thing," he says.

It can be difficult to find the time to do these creative projects, especially if you're not getting paid. But "if it's important to you," he says, "you'll make the time. If you're really a writer, you can't not write. The writers I know write every day because they can't not write; their heads will explode. The artists I know paint and draw

every day. On weekends they go to galleries to look at art. They are obsessed with it. You have to make time for your art."

Don says it's also always helped to have a designated space to create and dream.

"This is my ridiculous sanctuary," he says, looking around his historic two-story studio with surrounding gardens. "But, for many years, I just had a corner of a garage. And that was just as good as this. It really was."

Don never brings up money when he talks about creativity, except for when he talks about his dad.

"My dad was a preacher," he says. "We made $5,000 a year. But I never did this for the money. A lot of people do. A lot of people do it because they want to be wealthy. That's kind of a hollow existence. I always did it because I loved to tell stories, to go after the stuff that sticks to your ribs."

And he's still chasing that feeling.

"A dream is a living, breathing thing, so it's going to change and the goalposts are going to move," he says. "The dream isn't arriving because the dream is traveling toward that direction. It's that butterfly effect where you just plant seeds out there. Sometimes they don't grow and sometimes they do, and that is just a miracle. That's the joy I get when I think about what dreaming is. It's a leap of faith."

Sometimes, of course, he's taken leaps that didn't work out as he'd hoped. He's had many fallen soufflés. What does he say to himself in those moments, when the creative process doesn't lead to a dream come true?

"You should still feel a tremendous success that you did it. Because there are a thousand people out there who

didn't do it. And they wanted it as bad as you do. It's not like they're dumb. They just thought too much about the barriers, like, 'I'd totally love to do that but I don't have the money,' or 'I'm busy.' But you did it anyway.

"And I believe, maybe wrongly, that good things will come to you because your eyes and ears are open. You'll hear and see things you never dreamed you would when you left home. And that's the hero's journey story. That's the oldest story there is. And why do we like to hear it again and again and again? Because that's us.

"We take a leap. We leave our hometown. We have many adventures. We get kicked in the butt. And we return with a wisdom we never had.

"So dreaming, to me, is not about having a plan where you need money and all those things. It's about movement; you can't steer a boat that is not in motion. And then you can move in the direction of your dream."

✳ HOW OLYMPIANS PRACTICE
(JOE JACOBI)

Joe Jacobi's dream began at summer camp, when he was able to do a full kayak roll on his first try, his body firmly rooted in the kayak while he rolled underwater and then came back up again. People cheered, and he was hooked. He dreamed of being a high-performing kayaker one day. Not because of the accolades themselves but because of the relationships he made with the people who were giving them: fellow kayakers, some even professionals, who were part of the summer camp.

"I enjoyed the camaraderie of it all," he says.

That day was also the first time he'd ever felt like maybe he could be good at something.

"When you find something you are good at," he says, "it creates a sense of belief, like, maybe I can take this further and see what can happen with it."

His dream *was* to take it further. He wanted to be like many of the alumni of the camp who came back to help in the summers, the ones who were great at the sport and had even won championships. Joe got to know them and asked for help, and they took him under their wing and invited him to their practices.

"I was really lucky to be in this group," he says. "I was not very athletic, but I liked showing up. I liked the people." He also liked being in what he calls a "culture of excellence." After years of growing up in that culture, he could see how it changed him.

"I felt more comfortable with myself," he says. "I was in a safer place to take risks and experiment because I had people around me to pick me up if I made mistakes."

He spent years taking these "safe risks" in this high-performing and supportive culture, always trying to improve. It took a long time to get better, but he loved the slow process because he actually enjoyed it.

"I think for things that are really worthwhile, you don't rush it," he says. "You become fascinated with the process. You kind of fall in love with doing the basics."

He noticed that mentality in the champions around him. He also noticed that once they'd reach the top of their sport in any way, they were never that concerned about staying there. In fact, they never wanted to.

"I think really high performers like to get back to the bottom of the mountain quickly," he says. "They run back down because they want to get to that base level where they can do the fundamentals all over again. I think that is a big part of peak performance; it's not about staying at this fifty-thousand-foot ascended level forever. You go up and you come back down. You make yourself better, and then go back up again."

He dedicated himself to his training all throughout high school, until one night, he got home at three in the morning. He'd just been dropped off from a long drive after an early Sunday morning race that was ten hours away. His dad was furious that he got home so late on

a school night, and he didn't like how kayaking was getting in the way of school.

"This is over," he said, and sent Joe up to his room.

Joe cried the whole way up the stairs, but as he walked down the hallway, his mom peeked her head out of her bedroom door and whispered, "Don't worry. We'll go to the river after school tomorrow." And they did.

Around that time, white water kayaking was also added to the Olympics for the first time. Joe's mom drove him to the river every day to practice, and he kept practicing the way he'd learned at camp, only now he dreamed of competing in the Olympics one day.

Joe's mom kept supporting him, and his dad eventually became his biggest fan. Joe kept practicing, focusing on the fundamentals. But as he got older, he realized his commitment to practice, to his dream, came at a cost.

"It is natural to compare yourself," he says. "You look at friends you went to high school with, and they are having families, making money for the first time, and putting down roots. And you're out paddling up and down this river all day. It's scary to keep going at that point. But it's your dream."

So Joe kept going, hoping to qualify for the 1992 Olympics, only a few years away. But then, in 1991, he went over a drop on a rapid and dislocated his shoulder. He had to stop kayaking.

But he was not about to *stop*.

He rested, of course, and followed his doctor's instructions carefully in order to heal. But Joe decided to spend this new free time at the library at the US Olympic training center, reading everything he could.

"The rehabilitation process was actually really empowering," he says of that time. "I learned when you suffer any kind of injury—physically, mentally, emotionally, spiritually—you're given the choice to repair that injury. A lot of times when you repair something, you can repair it better than it was before."

His shoulder healed in time for him to compete in the 1992 Olympic Games in Barcelona, Spain, where he won a gold medal.

But that wasn't his dream come true, not really. His dream was always about something more, about the people and the community the sport connected him to. In fact, he got to know a lot of gold medalists who, after winning, were "so ready to be *done* with their sport."

But not Joe.

Decades after winning a gold medal, he still kayaks every week with people he loves.

✻ LOVING THE PROCESS
(WILL WELLS)

Growing up, Will Wells was always involved in sports, and he dreamed of being an Olympic athlete one day. But in July 2003, thirteen-year-old Will needed open-heart surgery due to a congenital heart defect they discovered almost too late.

Both before and after surgery, Will wasn't allowed to do anything that would elevate his heart rate, as increased blood to his heart could mean heart failure.

He couldn't play sports.

So, instead, he redirected his athletic energy into something else he'd always enjoyed—music.

When Will was cleared to play sports again—just in time for the start of his freshman year of high school—he was excited to get back to athletics, but he had also fallen in love with music.

He tried to do both sports and music for a while, but it was tough to do both. Eventually he realized he wasn't the kind of person who liked to do *anything* halfway. He needed to go all in. He needed to choose. He chose music.

There was no pros and cons list, no deep deliberation; music had simply drawn him in, and he couldn't get enough. His dream changed.

Will quit sports and joined every music-related after-school program, and often didn't leave his high school

until ten o'clock. Throughout high school he also sang in the choir, played the tuba and piano, and wrote music; he wrote so much, he filled a 460-page book with his original compositions.

Then one day he got a pamphlet in the mail advertising Berklee College of Music's Five-Week Summer Performance Program. It was the first time he realized there was a place people went to study contemporary music and that some of those people did music for their career. He dreamed of going to Berklee and becoming a professional musician. And he thought the best way to start would be to attend this summer program.

But then he saw how much it cost.

Will was the youngest of six kids, he explains, and they were a family of "humble means." They provided so much love and support, but they didn't have fancy-music-summer-school money.

But then one day his oldest sister, Tina, stopped by the house and saw the Berklee pamphlet lying on the table. She asked Will if he wanted to go.

He said yes. And she, now living out of the house and succeeding as an entrepreneur, paid for his tuition.

At the summer program, Will was thrilled to find so many other people who were just as obsessed with music as he was. *I am not the only one who literally sits up all day and just writes scores*, he realized. Better than finding his dream, he found his people.

He soaked up everything he learned from the Berklee Five-Week Summer Performance Program and even bought additional textbooks when it ended so he could continue studying on his own.

When it came time for college, Will got into Berklee, and even tested out of an entire year of school because of all the textbooks he'd studied at home. He worked all through college, at one point having three jobs, but his dream grew even bigger at Berklee. He felt like he was exactly where he was supposed to be.

He became known around the college, too, as the joyful guy who wore suits to class and was *always* playing or practicing. Because of that, he quickly became the go-to student Berklee staff recommended when professional artists reached out to the school looking for interns. When Berklee alum Alex Lacamoire, the music director for the Broadway show *Wicked*, called looking for help, they recommended Will.

Will worked as Alex's assistant for a new cheerleading musical, *Bring It On*, which Alex was working on with lyricist Lin-Manuel Miranda.

Will brought his same love and dedication to Broadway, and Alex Lacamoire kept hiring Will for project after project. And when Alex started working with Lin-Manuel on his original musical called *Hamilton*, Alex hired Will to be their electronic music producer.

To date, Will has worked with artists like Imagine Dragons, Logic, Wyclef Jean, Anthony Ramos, Quincy Jones, Barbra Streisand, DJ Premier, LMFAO, Pentatonix, and Cynthia Erivo; the song he worked on with Erivo was even nominated for an Oscar in 2020.

But for Will, the dream come true is being able to make his living working alongside people who love the music and the creative process as much as he does.

Chapter 6:

REJECTION, FAILURE, AND SELF-DOUBT

How to keep going when it really hurts.

✳ HOW TO KEEP GOING
WHEN YOU DON'T BELIEVE
(SARAH BALLARD)

Sarah Ballard's dream began freshman year of college, when her astronomy teacher put up a slide of a galaxy.

"It looked like two cotton balls," she remembers.

And the idea that each galaxy was made up of hundreds of billions of individual stars holding their own space transfixed her.

"All the hairs on the back of my neck stood up, and my mouth dropped open," she says of seeing that photo the first time.

At the time, Sarah was a liberal arts major, with a focus on peace and conflict studies; astronomy was just a class she picked on a whim to fulfill her physical science requirement. But she quickly found she loved doing her astronomy homework more than any other subject.

"I had never felt something so strongly—the feeling of, *I really enjoy this*," she says.

She told exactly three people about this feeling and asked each of them, "Should I change my major to astronomy?"

Sarah was so unsure of herself that had any one of those three people expressed even a hint of doubt, she may never have moved toward this dream. But instead, all three encouraged her to pursue astronomy and change her major.

"I don't know what it would have been like if even one of them discouraged me," she says. "That really was the moment where I was like, *This is what I am going to do*."

She changed her major to astronomy and loosely held a dream of being a community college astronomy professor one day. But mostly she focused on passing her new science-intensive classes.

"I honestly didn't even know if I would be able to pass my classes; I was trying to be brave. One step at a time," she says.

But sometimes, after taking a few of those steps, she'd stop; one time she was stumped on a homework problem from her Introduction to Astrophysics class.

"I looked at that problem," she remembers, "and was like, *I can't do this. It's too hard. It's too hard*. I felt like there was a brick wall in front of me. And what was written on the brick wall was what I couldn't do."

She'd stop to read what was written, but then, somehow, remembering the faint glimmer of a dream—of the feeling she got when she saw thsee two cotton balls of stars—she'd keep going, pushing through the bricks. Her efforts wouldn't be without pain, but every time she broke through and looked at the imaginary fallen bricks behind her, she realized the words they'd taunted her with were lies.

If only the lesson would stick. But it didn't, not for

a while; when the next brick wall appeared, as it always would, it was as if she forgot the walls she'd crashed through before. Each one felt new and impossible. Like that time she got a C on one of her first calculus tests and thought, again, *I just can't do this. I am not cut out for it.* But again, hoping for what might be on the other side, she kept going and simply studied harder for the next test.

She got an A on that one.

"I realized hard work is the currency," she says. What she learned helped her walk through walls despite, or rather alongside, her doubt. For a long time, Sarah's phone background was a photo she took of a piece of artwork she saw in a coffee shop once in Portland. The piece was created by artist Nicole Lavelle, and it said, "I can't do this but I'm doing it anyway."

Sarah graduated with her BS in astronomy. And although she really didn't think she would get into any graduate schools, she applied anyway.

She got into Harvard, where she pursued her PhD in astronomy. But even that didn't quiet her impostor syndrome; instead, it amplified it.

"I felt very uncertain of myself," she shares. "It seemed like at any given moment I would be unmasked, like it was preposterous of me to be at Harvard."

She also considered herself a gentle person and struggled to reconcile that with this idea of intense academic ambition. But no matter how much she doubted herself, she kept studying. And as the As piled up, that proof helped her eventually, albeit reluctantly, to believe, *I guess I am capable.*

Once, at a science conference Sarah attended as a graduate student, she sat at a table with a male professor

and two young female undergraduates who, with a degree of doubt and trepidation Sarah recognized immediately, expressed *their* dreams of pursuing graduate degrees in science. The professor abruptly and dismissively said, "When people apply to graduate school, they either have it or they don't, and you can tell right away."

The young women looked deflated, and Sarah, remembering how she might not have changed her major to astronomy if even *one* of the people she'd quietly shared her dreams with had discouraged her, shielded the side of her face adjacent to the professor with one hand and shook her head, silently mouthing to the young women, "No."

That was when her dream got bigger, when she decided that if she actually did ever become a professor, she would use that opportunity to encourage other doubtful dreamers.

After that arrogant male professor left the table, Sarah took the two women aside and gave them space to vent all of their self-doubt. She shared with them how often she felt (and still feels) the same way and told them, "It's one step at a time. Today, you try to apply. Tomorrow is when you think about whether or not you can go. Now, just apply."

Both young women followed up with Sarah later to thank her when they were accepted into and thrived in their science graduate programs.

Sarah continued her PhD at Harvard. While she eventually felt confident that she could pass her classes and graduate from the program, she started to doubt her ability to create and innovate once she *left* school.

"You will never have your own ideas," her doubt

said. "You can execute other people's ideas, but you can't create."

But then Sarah did start to have her own ideas. And in 2011, Sarah discovered a new *planet*. The attention that came after that was overwhelming. When *Time* magazine called her for an interview, she hid under a blanket (but still did the interview).

Then she was asked to interview for a job as a faculty member at the University of Florida.

Walking into the interview, Sarah looked at her phone and read, "I can't do this but I'm doing it anyway." She then reminded herself that she didn't have to teach a class today; today, all she needed to do was interview.

Sarah got the job and became an astronomy professor at the University of Florida, where she is currently advising four PhD students. She says of how she felt when her dream came true: "It turned out that I *could* do it, you know?"

✷ WHAT REJECTION CAN'T TAKE AWAY
(STACEY ASWAD)

Stacey Aswad dreamed of being an actor and entertainer. She attended the Juilliard School, and once she started auditioning, she learned how to hold big dreams and low expectations in the same hand.

"I have faith in myself and give myself permission to just go for it," she says, "but I have no expectations. If you hold onto every audition, every possibility, it's just such an insecure reality. So I don't really expect anything from anyone. I do my best, give it a hundred and ten percent, and then I walk on, knowing at least somehow there's a kernel, a seed that was planted, you know?"

Stacey always dreams big but never holds tightly to any particular ending.

"It's a really interesting balance," she says, "because I think when you have expectations, it becomes external. It becomes about other people's perception, what other people think you're great at, what other people think you should do. When you're trying to please other people and trying to meet other people's expectations, it's impossible for you to stay true and authentic to who you are. Your voice needs to be the loudest."

Plus, she says, "You can't dream big when you're worried."

It's not that worry didn't ever creep up for Stacey, but her bigger concern was always regret.

"I think the regret of not even trying is far worse than the potential of not realizing a dream," she says. "Because even if you don't quite realize that dream, the whole process you've been learning and growing, and perhaps what you thought you wanted is actually not it. Sometimes the setback or the challenge takes you in this other direction.

"When I'm really challenged, or especially when I'm exhausted or I'm getting told no more than yes, I go, *Okay. What is the lesson? What am I supposed to be learning? What am I supposed to be finding out?* Or, *Am I not supposed to be trying so hard?* Because sometimes, I think we try *too* hard. We push and then go, *How about now?*"

Stacey mimes a small performance as she says this, as if she's digging up seeds she'd planted only yesterday. "How you doing seeds?" she acts out. "Are you growing? What's going on down there?"

"They're not going to grow," she says, "if you keep unearthing them and going, 'Are you big yet? Are we there yet?' You have to let them rest. You have to water them with your passion, care, love, hope, and faith.

"It's like when you're on a road trip and you're watching the odometer. Stop looking at it. Stop looking at the end and just be where you are. Make the most of it because this might be where the biggest learning is."

Stacey talks more about seeds and patience than her own life story because, it seems, it's really the best way

she's learned to make sense of her journey: the audition lobby chairs, the walking in and out of casting offices, a career of waiting.

How did she endure the waiting?

"I think it's really about loving the process of it," she says, "honoring the teeny tiny breakthroughs, the little cool opportunities—so minuscule you have to squint. But any house is built with one brick, then another brick. It's not built in a day.

"It's a better foundation, I think, when you really honor where you are. Celebrate it. Because the smallest victory is still a victory. Especially out here, people ask, 'Oh, did you book the job? Did you book the job?' But to me getting the audition is a win. Think about the thousands of people who don't even get the audition."

Stacey realized quickly her dream would require a lot of auditioning and a lot of rejection, and she knew the only way she could survive that would be to frame it up in her mind in a way that would allow her to endure long enough to see progress.

"My job is to audition," she says of the mindset that got her through. "When I get a booking, that's like the icing on the cake. But my job is to wait and drive and audition. If I get it, that's great, but I have to love the audition. I have to love the process. I have to love the driving. I have to love the waiting. Because if I don't, then what's the point?"

Stacey knew auditioning was the life she was choosing, the path to the life she was dreaming of. If she didn't love the path (or at least most of it), why would she do it? She knew it couldn't be about only one particular destination because she knew she could never control that.

She learned to love the auditioning process, and because of that, she eventually did book jobs. First, she got the tiny ones she describes as having to squint to see, then some voice acting jobs, hosting jobs, and finally bigger roles that allowed her to begin to make a living as a performer—like the job she got with Disney, hosting a show that played 24-7 on Disney resort televisions for over fifteen years (a role for which she is beloved by many).

But, of course, even a big achievement like the hosting role didn't make the rejections stop. For every job she booked, there were many she didn't. But she kept showing up to the next audition, reminding herself that while rejection does hurt and may mean she isn't going to get something she wanted, the rejection can't take anything *else* from her *if* she doesn't let it.

"One thing I say to myself," she says, "is, 'What matters most in my life nobody can take away from me.' My family, my friends, my animals, my heart, my spirit, my hope. Unless I give someone permission to take that from me, they can't. So what's the worst that could happen?"

That doesn't mean the rejections don't hurt. They always do. But for her, that's not a sign she's ready to quit.

"What pushes us and knocks us down shows us what matters to us," she says. The pain reminds her that she still cares, and knowing that revives her, strengthens her.

"It's like this forest between you and your dream, and you say, 'Whatever. I've got bug spray, I've got a machete—let's go for it. Bring it on.' You know? If you're completely, 150 percent committed, there's no diversion that's going to take you off this mission."

But if, after recovering from the initial sting of a rejection, you come to realize you *do* want to stop, that this isn't worth it anymore, that's okay too.

"Maybe it isn't your dream," Stacey says. "Maybe it's someone else's idea of what you should do or you're trying to please somebody or you're trying to make up for some other thing you didn't do. If you can get knocked off your dream horse so quickly, then I always kind of question, was it really what you wanted? I think if you're very easily pushed away, you have to go inside and really look and say, 'Okay, is this really my truth?'

"I have found people I admire who've had incredible challenges, but they didn't go, 'Forget it.' They dug in harder, put their shoulders back; they did more."

There were seasons in her journey where she pushed harder too, but there was also a time when she decided it was time to let go, not of her dream, but of the *pushing*.

"At some point you just surrender and say, 'Okay, let's ride this out.' Because if you're going against waves, sometimes you just have to stop. You just have to float and let it roll over you, and *then* you keep going. Because you can also just completely hemorrhage all your energy trying to push against something."

Sometimes letting go and pushing less also meant Stacey booked fewer jobs, sometimes even none.

"I tried to use those times as an opportunity to do something else, like learn: take a class or a workshop. Or maybe I organize my closet. Maybe I make a photo book. Maybe I visit someone. I just look at slow times like, *Whoa, now I have a chance to do some other things that were on my to-do list that I haven't had an opportunity to do*. And I think it's important to put

money away and live below your means; I plan for those drought times, and look at them as opportunities to live a more balanced life than I normally get to live when I'm so busy.

"I keep making the choice to do this career, so I always try to find something good about even the darkest times.

"And I also think big breaks happen when you're most vulnerable, when you have surrendered and said, 'Okay, I am exhausted. I am tapped out. I have done everything, tried everything, said everything.' And still nothing is happening. But it's only your perception that nothing is happening. I think that's when it happens."

For Stacey, it happened during one of those waiting seasons, "waiting for the phone to ring; waiting for other people to decide if you were good enough or tall enough or skinny enough or blond enough or whatever enough."

After years of the ups and downs of the actor's life, even armed with all of the lessons, patience, fortitude, and seasonal thinking she'd gained, she had started to question if this was still what she really wanted. She loved performing and the entertainment industry, and she still really wanted a performer's life. But the more experiences she had with rejection, the more she learned what she was willing to sacrifice, as well as what she *wasn't*. For her, that meant she decided she wouldn't take any job that didn't align with her personal values.

"I don't want to do things that make me be less than who I am," she says. "Some money costs too much." But that choice also meant even *more* waiting. Even longer droughts.

And that's when she decided to take her career, and her dream, into her own hands.

After decades of only working the jobs other people offered her, the jobs she had to audition for, she finally created her own dream role: producing and hosting a popular on-camera show called *VO Buzz Weekly*, where she and her partner and co-host Chuck Duran interviewed other voice-over actors (as well as producers, casting directors, talent agents, etc.) about their craft, the ups and downs of their journey, and what habits and behaviors helped them succeed. When she started the show in 2012, she was one of the early adopters of this kind of online creator-led content.

"You can wait your life away," Stacey realized. While some waiting is necessary, she eventually grew tired of waiting on other people to give her permission to do her dream.

Today, Stacey is a full-time voice actor working out of her own home studio. She still produces her own content and inspires other performers all over the world to keep going.

"It's really a dream come true," she says, "being in the driver's seat of my life."

✷ WHAT WE CAN CONTROL
(JUSTIN BALDONI)

Justin Baldoni secretly dreamed of becoming an actor, especially after visiting sets with his dad, who worked in product placement. But it was a dream he never planned to do anything about.

"I was an ugly duckling," he says. "I don't think I ever thought that it was possible. It felt so far away that it wasn't even really an option. Sometimes dreams are so big and scary that we convince ourselves that we aren't enough to turn those dreams into a reality."

And then, when he was ten years old, his family moved from California to Oregon, where, even though he fell in love with theater, his secret dream of becoming an actor still felt a million miles away.

Instead, he poured most of his time and energy into sports, hoping to play soccer or run track at one of the best schools in the country. But then he tore his hamstring and lost all his potential scholarships.

Justin was lost. He didn't know what to do next. Depression hit, and then something in him called him back to California. He enrolled at Long Beach State College; there was, he says, a small, secret part of him putting himself back in radar range of an old dream.

In college, he met a girl who broke his heart, and one night, he escaped campus and slept on a couch in the LA office his dad still worked out of sometimes. The next morning, down the hallway, someone noticed Justin in the building and asked, "Are you an actor?"

"Nope," he responded, but what he said next surprised even him: "But I would like to be."

That guy turned out to be a talent manager, who pushed Justin to get into an acting class and started sending him to auditions. Justin asked his dad if he could drop out of school to pursue his secret dream.

"One year," his dad said. "You have one year. If you can start working in that year you can keep going. Otherwise, it's back to school."

Three months later, Justin got his first job as an actor, and a year later, he was a series regular on a popular show.

But his real dream, he tells me, the one he says that still drives him now, is "to live a life where my family life, passion, and career are aligned in service to humanity; it doesn't have to be big, in fact, often the most rewarding moments are the ones no one ever sees."

After acting for only a few years, Justin started his own production company, at first directing and producing music videos and commercials, and then creating content like the *My Last Days* docuseries, a show about how people who've learned they're dying choose to live out their last days.

"We forget that we have an end date, just like we have a birth date," he says. "I think the conversation of dreams needs to be balanced with a conversation of purpose and the idea that we're not completely in charge of the things that happen to us day-to-day.

"We think we are. A lot of people believe in this whole idea of well, *I manifested that, I made that happen*, like *I dreamed of becoming an actor and so I did it*. I think it's a mix. Sure, you became an actor like you had always dreamed of, but you also benefited from a lot of help from people along the way and a lot of coincidences—or as I like to say, 'help from the other side'—and being in the right place at the right time. You had to turn left at that moment on that street after you missed that turn, and if you hadn't turned left you wouldn't have met that person, but meeting that person was also a one-in-a-billion chance, so was it really an accident? There are countless things that happen in our lives that lead us to fulfillment of our dreams that I don't think people talk about. Sure it's us, but it's so much more than that."

And while good things happen along the way we don't expect or plan and can't control, so do of course the rejections and failures.

"I don't think we're as in as full control of our lives as we think we are, but we are in control of our reaction," he says.

Justin knows a lot about how to keep going even when things seem bleak; he has spent a good portion of his career—including the years during which he produced and directed the feature films *Five Feet Apart* and *Clouds*—making films about people whose dreams were cut short due to something *much* worse than rejection or failure: disease. He noticed how they reacted to the things they could not control.

"Every person I talked to when they were told they were dying," he says, "made a life change. The things

that they may have thought were important just simply weren't when put into perspective of their life being cut short. If they were giving their precious time to something that wasn't that important to them, they stopped."

In the face of the unimaginable, they focused on what they could control, and with whatever time they had left, he explains, they chose to pick up pieces of old dreams or new curiosities: they became photographers, musicians, world travelers.

"We have no control of when inspiration comes to us," he says, "but we can choose to act on it, right? That same idea may come to a hundred people around the world, but only a few will ever do something with it."

Justin talks about the people he's documented so much more than he talks about himself. It's hard to get him to say much about his own journey, but he talked a lot about Christopher Aiff, quoting something Christopher said in one of the *My Last Days* documentaries: "'The decision to be positive is not one that disregards or belittles the sadness that exists. It is rather a conscious choice to focus on the good. And when we devote our energy and time to trivial matters and choose to stress over things that ultimately are insignificant, we perpetuate our own sadness and lose sight of the things that really make us happy. We rationalize our way out of doing amazing things.'"

✱ WHEN DREAMS DIE
(STEVE LEWIS)

As a kid, Steve Lewis had exactly three dreams: 1. to be a musician; 2. to train a great white shark (so it could be his buddy); 3. to own a comic book store.

He started with the music dream, playing in a band when he was a teenager, and eventually becoming part of a heavy metal band called Bubblegumm. While playing shows, Steve noticed how much time people spent worrying about what *other* people thought of them.

"Growing up," he says, "I didn't agree with the mindset of the people around me. I thought, *I don't want to be like that when I grow up.* So I remember asking this one question to myself all the time: *Does this represent who I am as a person?*"

Steve asked himself this constantly because what he wanted more than anyone else's approval was his own.

"I wanted to be true to who I am and not a product of the world around me," he says. He sensed early on how viciously the world can drown someone's voice, personality, gifts, and courage.

Steve's commitment to self-expression often drew other people to him, people who may not have felt free enough to be who *they* really were but who were drawn

to someone who was doing just that. His band grew a following, and Steve was making a living in music. He was living his dream.

But then he injured his left hand, and, after a botched surgery, he couldn't play guitar anymore. His number one dream was dead. And music was the only way Steve had ever expressed himself, the only way he had connected to other people; when it ended, he was more lost and melancholy than ever before.

So he went to the kitchen, and he baked. That's what he always did when he was sad, something he'd started when he was young, after his parents divorced and he was taken away from his mom by family members who didn't approve of her once she came out as gay.

Steve found solace in baking then, finding boxes with muffins or cakes on the front, pouring the dust into bowls, but never following the instructions on the back. Steve would experiment, add things, tinker, and play. Baking always helped him keep going. As he got older, whenever he got sad, he worked on a chocolate chip cookie recipe he was trying to perfect, seeking the taste he longed for when he moved to Florida and couldn't find the kind of cookies he had been used to in New York City. So after he had to leave the band, he baked cookies and tried to figure out what to do next with his life.

He remembered his three dreams. One had died, and the second, well, he didn't know exactly where to begin with his shark dream, so instead he decided to open up a comic book shop in Winter Park, Florida. He called it Überbot. And since he didn't have a great white shark as a buddy, he got another—Lupin, a small Alaskan Klee Kai that never left his side and even came

to work with him at Überbot every day. Überbot (which also doubled as an art gallery), was another dream come true for Steve.

"Watching the look on people's faces when they walked into the store for the first time and were inspired by the art," he says, "or excited to talk about comics, really gave me the comfort and connection I was missing."

But in 2009, Überbot "crashed and burned" along with the entire economy.

"I outlasted the Starbucks in the Winter Park Village where I was at," Steve says, "so that's my claim to fame. But I lost everything. I lost my house. I lost every penny I had."

Not too long after Überbot closed, Steve took Lupin to the vet for her routine checkup, and the vet said she was in perfect health. Days later she passed away in Steve's arms. They never knew how or why. She was just gone.

Steve was wrecked. His bond with Lupin was the closest he'd ever allowed himself to build, the first family he chose, and the loss left him feeling as alone as he had felt as a kid when his family imploded.

"I couldn't move," he says of the moments after. "I locked myself in my house for three weeks. I remember my mom banging on my front door, and I wouldn't answer. I was working on my cookie recipe. I remember crying into that cookie dough and finishing the recipe then because I decided I would dedicate it to my dog. I thought, *This is it. I'm never touching this recipe again. This is your cookie, Lupin.*"

Eventually, needing to break from isolation, Steve started sharing his cookies. People loved them, exclaiming, "You should sell this!" But Steve was skeptical.

"Everybody says that to anybody who makes any-thing," Steve says, "I didn't really believe it was possible."

But he noticed that when people expressed joy after taking their first bite of a cookie he made, he felt the same feeling he used to feel when he talked about comics to customers in the shop or played music for others on stage. He loved sharing what he loved. While most forms of connecting with people didn't come naturally to him, this kind of connection did.

And while it brought him comfort to connect with people again through his cookies, he still felt more lost than ever. Losing the store and then Lupin felt like his hand injury all over again, but worse. Another dream had died, and this time, he didn't have any other dreams left. After losing all of his dreams, he had a kind of nervous breakdown.

"It was a rough few years," he says. "But while 90 percent of it was grief and pain, 10 percent was a healthy perspective of how to move forward. And as the days and months moved on, that 10 percent started to turn into 15 percent, then 20 percent, as I slowly started to climb out of that hole."

He also had to get a job; the loss of Überbot put him in a lot of debt. Steve got a job at an Apple store. His coworkers also raved about the cookies he shared with them, and he started to wonder about starting a small side gig of sorts, maybe making money by baking cookies from his house. But unlike his other romantic dreams, this thought was pragmatic. He was in debt and needed money. He thought maybe the cookies could help.

When Steve wasn't working his day job at Apple, he experimented with new cookie flavors, thinking he'd

probably need to have some variety if he was going to sell them. He played with ingredients just like when he was a kid, only this time, afterward, he invited his coworkers over for taste-testing parties.

"I would give them this sheet," he says, "and I would have them rate which ones were their favorite."

Once he finalized his flavors, he started selling his cookies from his house. He bought a chest freezer and spent the first week of every month making dough and then the rest of the month selling the cookies.

Pretty soon, there was a three-month waiting list. Some people were even buying the cookies and then reselling them for double the price.

"That's when I thought," Steve says, "maybe I should start taking this a little bit more seriously."

He also realized the cookie business was doing a lot more for him than just helping him pay down his debt. "I found that for me food is almost identical to music. The cookie was my song now."

So when it came time to play his first "show," a pop-up at East End Market in Orlando, he felt ready. To prepare for his month-long pop-up stint and to stay ahead, he made three-weeks' worth of dough, a calculation he made after talking to previous pop-up vendors and asking what they sold each day.

It was a great plan. But he sold out of his entire three-week inventory on the first day.

And that's when he knew.

"I saw the whole picture on that day," he says. "Like, okay, *This is what I need to do.*"

Once the cookies turned into a new dream, Steve went into "what if" mode, creating with the same

dedication he once gave to Bubblegumm and Überbot. He got a permanent, albeit tiny, location in East End Market and named it Gideon's Bakehouse, inspired by a boy named Gideon who had doodled his dreams of owning a bakery in the margins of a vintage cookbook from 1898.

Steve designed the bakery in a Victorian style. He loved crafting its slightly haunted-library motif; he even added his own vintage books to the shelves and secured an old light that was once in Disney's Haunted Mansion.

After the cookies took off at East End Market, Steve dreamed an even bigger dream; he imagined opening a second Gideon's location *at* Disney one day. Steve had always loved the attention to detail at Disney. He knew getting a location there was next to impossible, but though he was melancholy by nature, that never stopped him from dreaming impossible things. It might be ten or twenty years down the road of course, he thought, but that was fine with him.

He was in no rush to pursue such a big dream. He was more than content with his tiny nook in East End Market and one employee. He was also incredulously happy that he was able to now make a living for himself with a few cookies. That was more than enough for him.

But then he got a girlfriend. And she, he says, wanted more in life.

"I was very much in love," he shares, "so I thought I needed to get responsible about the business side of what I did and be a respectable earner so I could take care of her."

He decided to start moving forward with his bigger dreams.

To begin, he struck up a partnership with the Polite Pig, a restaurant on Disney Springs property that was owned by another Orlando business that had made the move to Disney. Steve offered up his cookies to them as a secret menu item. They agreed, and on the first day the cookies were available at the Polite Pig, the Disney Food Blog took a picture of one and proclaimed it to be the best thing to eat on Disney property.

It didn't take long for word to spread; the cookies sold out faster and faster each day. And a few weeks later, Steve was in talks with Disney about opening a second Gideon's Bakehouse location in Disney Springs.

"One of the beauties of failure," Steve says, "is that it forces creativity. If it weren't for the loss of Überbot, I wouldn't have been pushed in this direction."

And while the Disney doors opened fast, the doors to his bake shop location at Disney Springs wouldn't open for another three years. It wasn't slow because of Disney, Steve says. "It was a three-year conversation because I'm stubborn. I wouldn't say yes to anything unless it was what I envisioned in my head."

This business, right down to its location, is personal to him, an extension of him.

"The brand is not a theme that I created for the bakery," he says. "It's what my brain would look like if you cracked it open."

He managed to keep a grip on that part of his creativity, even as he got older and suffered losses, by continuing that early musician's commitment to not letting the world (or losses or failures) dilute who he was. The world could kill his dreams, but he wouldn't allow it to rob him of who he was and what he could give.

When Gideon's Bakehouse finally opened in Disney Springs, traffic backed up for miles. By 11:30 a.m., the wait to get one of his cookies was twelve hours.

When he walks into the Disney Springs shop now he says, "It reminds me of the side effects of believing in yourself, of thinking about the greatest possibility and shooting for it. At the end of the day it makes no sense that a nobody like me is out there. It's impossible, but somewhere along the line, I convinced myself it was possible. And, you know, it wouldn't have existed without all of those previous failures."

Part 3:

the pain

"*What do you think the word impossible means, young one?*"

"*Impossible means something that can't be done,*" *Assata replied.*

"*That is the definition for some,*" *M'Baku said. "But for people who refuse to give up on their dreams, impossible simply means you have to find another way to make something possible.*"

—Frederick Joseph, *Black Panther:*
Wakanda Forever: The Courage to Dream

Chapter 7:

STOPPING

It's never too late to start again.

✳ WHEN CHILDHOOD DREAMS RETURN
(MICHAEL BRYANT)

When Michael Bryant was ten years old, he was enamored with Jacques Cousteau specials on TV; he thought being underwater seemed like flying, and he dreamed of learning how to scuba dive. But Michael lived on a farm, three hours from the nearest ocean.

So he went to the library to look for books on scuba diving. He found only one: *Scuba Diving in Southern California*. It was an illustrated guide of all the best places to dive in Southern California. Michael's favorite was Diver's Cove in Laguna Beach. He spent hours in his room with that book up to his nose, staring at that two-page panoramic spread of Diver's Cove, pretending he was scuba diving there.

"I got really good at imagining it," he says.

He checked that book out from the library every week for two years.

"I was the only one who checked out that book," he laughs. But without access to an ocean, the dream eventually faded, and Michael stopped checking out the book.

Instead, he focused on something he could do with what he did have around him—dirt. Michael became a professional dirt bike racer, traveling the country to

compete, and eventually moving to California. Once he saw the Pacific Ocean, he remembered his old, cherished library book.

He signed up for scuba lessons.

The first phase of lessons began in a classroom, then they moved to a pool. Then, to get certified, they began a series of open water dives.

No one knew what the last open water dive before certification would be, because the instructors didn't want anyone to research the location ahead of time; it was important for certification to test that the divers could follow drills in a new location.

Michael's heart pounded when he pulled up to the address for their last dive because he knew exactly where they were: Diver's Cove in Laguna Beach—the same beach he'd spent most of his childhood staring at in a book.

He got a little choked up as he walked down the stairs to the cove, scuba gear in hand. He stepped into the icy water, and thought, incredulously, *I planted this seed in the fourth grade.*

✳ WRITING THINGS DOWN
(ADE HASSAN)

Ade Hassan dreamed of being an entrepreneur in the fashion industry, though doing what, exactly, she didn't know. But she collected ideas constantly and even kept a notebook by her bed.

The idea that sparked her most came as a result of many frustrating shopping trips, when she couldn't find lingerie or hosiery that matched her skin tone. So-called nude tones at that time only represented a very narrow selection of skin tones, none of them hers.

Even online, she couldn't find *any* "nude" undergarments that matched her skin color. *You know what? This is it*, she thought.

Then she texted a friend: "I think I figured out what I want to do when I grow up." She wanted to create a line of lingerie that more closely represented all the beautiful shades of nude that so many brands left out.

Ade woke up constantly in the middle of the night to jot down ideas in the notebook on her bedside table, like potential names for colors or rough sketches of what she wanted a piece to look like.

But beyond her now very full notebook, Ade wasn't sure what to do next. She had *no* idea how to actually

make physical products, and she didn't have the money, or the time, to take on such a big project. Her finance job required all of her waking hours.

For the next two years, Ade's dream stayed frozen in a notebook beside her bed.

Then one day she got a card in the mail from a college friend, Meera, whom she'd stayed with a year prior when Ade was in New York for work. Back then she'd told Meera about her idea, and Meera thought it was *fantastic*.

A year later, Meera sent Ade a card for her birthday. The front of the card said, "It's time to start living the life you always imagined." On the inside Meera wrote, as Ade explains it, "how proud she was of me, and how she was so looking forward to this company, and how she couldn't wait to see me on the cover of *Forbes* one day."

The next day, Ade registered and trademarked her company. She called it Nubian Skin.

Then she started googling manufacturers who could make what she wanted and contacted every single one. But no one got back to her.

"It is the most devastating thing when you are so excited about something and so passionate about it," she says, "but you feel like you can't get anywhere, like nobody gets what you are trying to do."

She decided to ask for help.

Through online research she found a business consultant who specifically helped people in the fashion industry. Ade showed up for an initial consultation with her business plan in hand, and the consultant encouraged her. "She said she sees a lot of ideas, and this one was actually legit. She told me I needed to find a manufacturer and go to trade shows."

Ade hired the consultant, who helped her find the inroads she needed with the right manufacturers and trade shows. Then it was just a matter of working out shapes and colors, but that part Ade had no problem with—that was the part she'd been working out in her notebook for years.

She also kept learning, reading every book she could get her hands on about the fashion industry and what it takes to start your own label.

Once she found the perfect manufacturer, she got her first samples in. But the colors weren't right. She kept going back and forth, but it was starting to seem like no one could make what was in her head.

That long back-and-forth process was stressful.

Sometimes, she says, "you think when things are not going your way, you should just stop."

But she had already stopped before, and she didn't want her notebook to stay closed anymore. She knew now that she wanted this. She kept going. She focused on not seeing every "wrong" sample as a failure but as a chance to troubleshoot and get one step closer to her vision.

Ade says the process was still a million times harder than she thought it would be. But every time she felt like stopping again, she checked in with herself: Did she still believe in the end result she was hoping for? If she did, she would keep going. And she did. (And even when she didn't, she borrowed belief from her mom and friends, who were now big believers in her dream too.)

It took a year and a half for her to finally get to a sample that matched her vision. She made her first product order, and in August 2014, she had her first photo shoot showing her products on models representing all

the skin tone options she'd created. When they were ready, she put those photos on the Nubian Skin Instagram page (it had ten followers).

That was the last thing she did before she went on a long-overdue vacation.

But on the first day of vacation, she kept getting interrupted by her phone's constant buzzing.

What is this noise? she remembers thinking. *It's so annoying.*

She checked and saw she'd gotten ninety new Instagram followers that day. By the end of her vacation, she had three thousand followers.

"It was phenomenal," she shares, "because it was all of these different communities of color basically saying 'This is amazing,' that someone is finally acknowledging what they want."

It was the first moment she felt truly grateful she'd kept going, that maybe she wasn't crazy for thinking this could be a good idea, that maybe she could play a small part in helping more women of color feel seen by an industry that had for too long ignored them.

Not too long after Ade shared Nubian Skin online, actress Kerry Washington tweeted about it. By the end of Ade's first month in business, her Instagram account had twenty thousand followers. Ade remembers when she first shopped around her idea and people said, "Nobody needs that." She's glad she didn't listen, and that she kept going anyway.

★ BRINGING A DREAM
OUT FROM HIDING
(WESLEY WHATLEY)

The first time Wesley Whatley picked up an acoustic guitar, he started writing songs. Songwriting just came naturally to him; it was one of the first times he felt like he could really express himself. And he secretly dreamed of one day writing a song that might connect with others.

But he wasn't sure about pursuing music as a profession or studying it in college since it didn't seem quite practical, and he had many interests. When talking to his dad one day about what to do for college, he was surprised when his dad said, "Son, go major in whatever you love the most. You love music and I've seen your talent. Follow your passion."

His dad grew up on a farm and became a successful businessman, and he thought studying something you loved *was* a practical choice. Four years is a long time to spend in school; why waste it doing something you don't love?

Wesley spent four years studying music at Stetson University. There, he started to understand why his dad

thought passion could sometimes be practical; when things got hard, it was the love of what he was doing that got him through.

"When I'm confused and I'm lost and I'm unsure," Wesley says, "I always go back to this idea: *Where's the fire burning most in my gut?* If I'm at a crossroads, I ask, *Which path inspires me the most?*"

After graduating from college and working in Florida for a time, Wesley was offered a high-profile job in the entertainment industry and moved to New York City.

"Walking through the city and working with artists and people who are just so engaged and excited really spurred my dream forward," he says, "because I saw other people achieving their dreams, and I recognized that this city was a place I could really reach high and dream big."

Wesley worked at a company where music was a part of his life, but he wasn't the one making music early on. For years, most people didn't even know he was a song-writer, until one day he just decided, "You know what? I'm going to get up in the West Village and I'm going to sing my original music for my New York friends."

He booked a slot at a club in the West Village and invited friends and coworkers. His invitations said, "Just come join me; I'd like to share a part of my soul." It had taken him years to build up the courage and the song list, but he finally felt ready.

He was nervous but also excited to finally share his music, a dream he'd shared with only friends and family.

The show was booked at the Duplex at 61 Christopher Street and Seventh Avenue for February 11, 2006, at 5:00 p.m. The show was called *Georgia Boy,* and the flier said, "An evening of acoustic music with Wesley

Whatley featuring original songs dealing with first loves, growing up, and coming out of the Deep South." The bottom of the flier said, "Donations will be accepted for the 2006 AIDS Walk."

But then, on February 11, 2006, a major snowstorm hit New York City, dropping twenty-two inches of snow. No one was going to show up to his debut now, he thought.

Except everyone did. With coats draped over chairs and snow melting under shoes, Wesley's friends gathered in the club that night to listen to him play the eleven original songs he'd written over many years.

Most friends knew he could sing, but very few in that room knew he was a songwriter. The response was electric and full of love, he says. "The confirmation from these people in the room that I care so much about felt like the universe saying, *You can connect to people through music. Do more of it.*"

Wesley kept writing, on his own and with other people—like Bill Schermerhorn, Wesley's boss at the time and the person who'd hired him to work in New York City. When Bill saw Wesley perform his original songs that night, he went up to him afterward and said, "We should write together."

For the next few years, Wesley wrote many songs with Bill, including a few musicals.

"Writing with a collaborator was scary," he says. "I didn't want anyone else to see or hear my bad ideas. But soon I found that we both have strengths, and when we argued, the final result was usually better than either of us could deliver on our own. Sometimes it's also nice to have a partner start an idea that inspires me. Working alone can be exhausting and a lot of pressure."

One of the songs they wrote together, "I Believe," was nominated for an Emmy Award.

Wesley walked the red carpet on the night of the awards show with his mom by his side. But the song didn't win that evening.

"No matter what anyone says," he says, "it is a disappointing moment."

The next morning, he took his mom to a diner for breakfast, feeling deflated but trying not to let it show. They ate in silence until his mom looked at him from across the table and said, "I've never been more proud of you."

"In that moment," he says, "I learned to celebrate the work, to celebrate the music and the performances, the art of it all, and not worry about anything else that comes. Nominations on this stage are truly special, and I'm grateful, but over the years I'm learning the true honor is simply to work in a city like New York and contribute in my own way, hearing from an audience that a song moved or inspired them. As a writer, I'm honored just to be doing it."

Wesley kept writing, as he always had, and, because of that, he says, "When disappointment comes through, it's not difficult to pick up the guitar again and just keep playing."

He still had some fear around sharing his work, though.

"It's so much easier to stay in my apartment with my guitar and keep my work there," he says. But he couldn't forget how wonderful it felt playing his first show; how, for him, the act of sharing his art is what makes him feel most fulfilled. It was a risk to share his work, and it always would be, but, he says, "By taking the risk, doors open or new pathways reveal themselves."

Years after their first Emmy nomination, Wesley and Bill were nominated again for another collaboration. This time, Wesley celebrated the nomination itself, along with friends. He showed up to the award show with no expectations, having already celebrated the success.

And that night, they also took home a gold souvenir.

But the real night that changed Wesley's life was the one where he crunched through snow in 2006 to share the songs he'd kept in his room. After that show, he booked a slot at another club for six months later, even though he wasn't sure if he'd have new music.

Whenever he'd get scared, he'd tell himself, "Just book the club. And have faith that the songs will come."

✴ WHERE YOUR HEART RETURNS
(JACKIE JOHANSEN)

For Jackie Johansen, the library was the one place where it felt like "the sky's the limit." She dreamed of writing a book that would one day sit on a library shelf.

"There was never a clear *I'm going to do this and make this happen*," moment, though, she explains. The process was more nuanced, starting with simply noticing where her feet and heart kept going: "I kept going back to the library. I kept going back to bookstores. I kept picturing it."

But she didn't put up a vision board or write her goals down every day. She just wrote. And not with any particular goal or dream in mind, not really. She just loved writing.

It started with journaling. Then, poetry. Writing helped her feel strong, especially when she felt insecure. It also helped her form her own opinions, find her voice, and find strength to keep moving through life. So she chose to study literature and writing in college, with practical ambitions of becoming a high school English teacher. But, unlike her experience in libraries, the closer she got to the teaching world, the *less* at home she felt.

She did love her psychology classes though, so after college, she pursued a graduate degree in psychology and got an internship using expressive arts therapy, which included working with women in drug and alcohol recovery.

"The creative arts help people process their stories and find their voice," she says. "It helps them stand taller in the world."

While Jackie immersed herself in this work, her dream of having a book in the library faded from immediate view, though it still remained. But she stayed focused on what was in front of her, not worrying about where she wasn't yet.

"You have to trust yourself, the process," she says, "and trust the spark. It's there for a reason. When we follow those creative impulses, we start moving closer to our greatness, shining brighter."

The final step in Jackie's graduate program was to write a thesis. She was excited to work on such a big writing project, but it also brought with it the resistance, fear, and doubt, she says, that often accompany the writing process.

"When we write, we are sharing parts of ourselves. The vulnerability of being seen and not accepted freaked me out."

But instead of keeping her fear to herself, she started sharing the ups and downs with others. In doing so, she found a writing community, a group of people who felt the same way and normalized the ups and downs of the writing process. It helped her keep going and finish her thesis.

"I put my heart and soul into it," she says.

The last step was to print and bind the thesis. There at her college print shop, smelling the fresh ink in the air, watching the crisp pages slide out one by one, she finally realized: she hadn't just written a thesis. She'd written a book. And that book would sit on the shelves of her college library.

"If I had planned out a goal to get my book in a library," Jackie explains, "I might have gotten overwhelmed. But it was the writing that was such a calling for me and still is. That is where my heart returns to again and again."

✴ WHEN YOU STOP DRAWING
(PETER REYNOLDS)

It's difficult for Peter Reynolds to say what his exact dream is on any given day, but he calls himself a dreamer. He doesn't know what it's like *not* to dream. For him, dreaming isn't a one-time thing, it's who he is.

"I've been dreaming and using my imagination since I was a kid," he says. "I was one of the lucky ones because I just never stopped."

As a kid, Peter loved drawing and remembers receiving a lot of encouragement; but then, as time went on, he noticed more and more teachers saying that he should draw on his own time, not during class.

"Eyes up front. Focus," they'd say to him.

But in seventh grade, a math teacher noticed Peter drawing in class and *didn't* tell him to stop. Instead, that teacher gave him a special project to teach math using drawing and storytelling.

"I came up with a comic book to teach math to other kids," Peter remembers. "Mr. Matson really connected the dots for me by saying, 'Hey, you can take your art and your storytelling, and you can connect it to something. You can tell a story; you can teach with it.'"

Peter never stopped drawing. When he grew up and had a daughter of his own and started reading her children's books, he got an idea to write and illustrate one of his own.

"I actually didn't even think about it too much," he says. "I just knew that I could write and draw so I decided to start making my own stories for her."

Since Peter had never stopped drawing and had never squelched his imagination, he didn't contend with a lot of drama or self-doubt. He pursues things more like a kid, jumping into whatever sounds fun.

His first book was called *The North Star*. It was about dreaming.

He also started his own publication company with his twin brother Paul, called FableVision. Having his own production company gave him more freedom to follow his creative whims.

Then one day a local publisher, Candlewick Press, impressed by *The North Star* and Peter's drawing style and sensibilities, asked him to illustrate a new book coming out called *Judy Moody*.

Judy Moody became a beloved series and a feature film. Peter continued making his own books, following wherever his imagination took him, including to the streets of his hometown, Dedham, Massachusetts.

"I walked by an empty storefront and looked in and I could actually see a bookstore. I went home and I made a watercolor sketch of this bookstore, with big oak bookshelves and places for kids to read. And it would also have art supplies and toys because play is important too. Wouldn't you know it? Six months later we opened up the Blue Bunny Bookstore."

Another dream. Another drawing. Another reality.

"Once you get good at dreaming," Peter says, "the dreams take root and then one dream leads to another dream. Dreams have this habit of rippling out.

"Having a picture book was a dream come true, but it wasn't like I set out to say, 'Oh my dream is to be a children's book author.' My dream was really to help kids like me in school be heard and encouraged, to inspire people *not* to put the pencils down."

When Peter visits schools as an author, he encourages kids to embrace who they are and not let anyone squelch their natural imagination or sense of direction.

"The opposite of dreaming is to be on autopilot and let other people make your decisions for you," he says. "But if you are creative and you do have a dream, it's going to be a lot of hard work because you're the architect of that dream. And there are days where it does get overwhelming."

What does he do on those days?

"I actually will stop working," he says. "Stop trying. And be okay with it. I walk away and take a break. I usually go get a coffee in my bookshop café.

"I always describe it like [being] a surfer, waiting for the perfect wave. If you don't see the perfect wave, don't stress out about it; go up to the snack bar and have an ice cream."

When that inspiration does return, one of his favorite things to do is go to a busy place like a restaurant, toting along his dog-eared sketchbook.

"Then I'll write whatever comes, draw whatever comes, without a plan. It doesn't need to make sense. You can make sense of it later on. That's the beauty of

dreaming. It's fueled more by imagination than logic. That's how breakthroughs happen: capturing ideas unfettered by the heaviness of reality."

✳ CHANGE YOUR DREAM
OR YOUR TIMELINE
(KYLE ROHRBACH)

Kyle Rohrbach dreamed of being a producer one day, especially after he fell in love with planning his high school talent show. He *loved* orchestrating the event, recruiting performers, managing the logistics, and then seeing it all come together in a single night that everyone could enjoy. He didn't know quite what a producer was then, but he knew he'd never felt more alive than when he was planning his high school talent show.

His dream got a name when he met Mark Wolfe, a movie producer who happened to be a part of the same homeowners' association as Kyle's grandma. Knowing Kyle was fascinated with entertainment, Kyle's grandma asked Mark to meet with her grandson and give him guidance. Mark agreed, and they met for coffee. Kyle laughs as he remembers his mom picking him up and dropping him off because he didn't have a driver's license yet.

Mark noticed how Kyle lit up when he talked about the talent show. Mark asked him questions like, "What were your responsibilities? What did you do? How did you make it happen?"

Kyle told Mark everything, and Mark responded: "That's a producer."

Kyle left that coffee with a name for his dream and a mentor.

Kyle's parents insisted he go to college first, so he obliged and got into the school for film and television at New York University (NYU). Kyle moved from his home in California to college in New York and hoped to learn everything he could about producing film and television. Every summer he went back home to intern with Mark, helping Mark produce live events or working as an assistant for an independent film Mark was doing with *Reading Rainbow* legend LeVar Burton.

"It was almost like doing the talent show," Kyle says of those days. "I remember going in early, staying late, doing it all the time."

He loved it. And they loved him; they even asked him to stay after one summer to finish the film through the fall.

"I had a big fight with my parents," Kyle says, "because I desperately wanted to stay and finish the movie, and I promised them I would go back to school. But they didn't believe me so they pulled the 'if you don't go back, we won't pay for the rest of your school' card."

So Kyle went back to school.

Later that year, Kyle's girlfriend told him she was pregnant.

"People who are important to you look at you and go, 'What have you done?'" he remembers. "And some of the more candid people said, 'I hope you know that if you choose to have this child it's going to ruin your life.' They said you can't possibly follow a dream or

a passion if you have a kid young." But Kyle and his girlfriend wanted this child. "So things changed," Kyle shares simply. But their dreams didn't.

Kyle and his girlfriend had a baby boy in 2008 and named him Aiden. In 2009, Kyle received his diploma at the NYU graduation ceremony. And while many people likely zone out during the ceremony and can't remember a word said by their graduation speaker, Kyle remembers something the dean of the arts school, Mary Schmidt Campbell, said that day.

"You are all artists," he remembers her saying, "and most of you have a passion for what you do, which is why you're here. If I can lend you any piece of advice to be successful professionally with your passion, you need to treat it like it's your own child. Similar to a child, an artistic passion starts without the ability to walk on its own. It needs nurture, it needs time, it needs patience, it needs commitment; it needs everything a baby needs. Eventually it will learn how to walk."

Then she laughed and said, "I know most of that means nothing to you because you don't have children yet."

But by then Kyle had a seven-month-old; he knew exactly what she meant, and he was grateful. "This light bulb went off, like, *Okay, I need to treat my passion like I treat Aiden.*"

Everyone expected Kyle's dreams to die because he had a kid, but they only grew. He knew, however, that the timeline and path would have to change.

"Before having a kid," he says, "the plan was to graduate from school, go make movies, and live in my parents' house for free until I could make money doing movie stuff."

He knew his dream might happen more slowly now. He would need to create a new timeline, but that timeline now included his son and he didn't regret that at all. The way he looked at it, he says, "I had two children to support."

Kyle also hoped his son would see his commitment to a dream and know possibility in his own life. But with two "kids" to support and living on his parent's couch no longer a viable option, Kyle knew he'd have to get creative and rethink what kind of risks he could take for his dream *without* risking Aiden's wellbeing. The other graduates in his class were risking everything on their own independent films, self-funding their dream projects, and taking them around to festivals. That sounded wonderful but not quite responsible for Kyle given his new priorities.

"That was a risk that I didn't feel comfortable taking," he says. "I could have, but I didn't feel comfortable taking it because I felt like the odds were that it probably wasn't going to work in my favor and that put Aiden in too much risk." Kyle was willing to make sacrifices for his dream but not willing to sacrifice his son; Aiden would always come first.

Kyle needed to get a job, and fast, especially because his girlfriend, now his wife, still had one more year of nursing school to complete in New York.

"'You're never too good to flip burgers,'" Kyle says, quoting his mom. So after he graduated from NYU film school he got a job in food service and then got a job at the twenty-four-hour Apple Store in New York City. When his wife finished nursing school, they moved back to LA.

"I had said to myself from the beginning that when I finish school, I'm going to move back to Los Angeles

because that's where this industry is," he says. "It's in New York too, but a lot more of it is in LA. Mark played a big role in that too because I knew he was there. This is an industry where they say it's all about who you know, and he was who I knew."

Kyle transferred to the Apple store in LA and connected with Mark again. At the time, Mark and LeVar Burton were still working closely together, developing a new project to bring *Reading Rainbow*, a kids' show that originated on PBS and was hosted by LeVar, back into the world somehow.

Mark told Kyle, "I know that you have a full-time job at Apple, and we can't pay you; it's just the two of us. So you'd be the third guy. We can't pay you right now, but any spare time that you want to give to us, to read scripts, help us with our calendar, set up email, by all means, that's available to you." Kyle said yes and did that work on top of his day job at Apple.

Around that time, the first iPad came out. When Kyle and the team realized kids were going to be using these devices and reading on them, they started developing a new *Reading Rainbow* program for the iPad. And Kyle realized that the day job that had felt like a departure from the dream actually helped him on the way to it; his tech experience became vital to the production of this new project.

And when his wife graduated from nursing school and got a job at UCLA, they decided it was time for him to quit his day job and go all in with LeVar and Mark on this new project of bringing *Reading Rainbow* to the digital space.

"It was still risky to have a single income," Kyle says, "and we were living in an apartment in the Valley.

It wasn't glorious living, but it was like, *You know what? This is an opportunity.*"

Soon after, Kyle produced the Kickstarter video for the *Reading Rainbow* project, which went viral and generated over one million dollars in funding.

That's when Mark was able to hire Kyle as a full-time producer.

Becoming a producer took longer than Kyle had ever imagined, but he says he can't imagine it happening any other way than with his son cheering him on.

✶ IT'S OKAY TO STOP
(KIMBERLY BRYANT)

When Kimberly Bryant took her daughter to her first day of summer coding camp and noticed her daughter was, as she shares, "the only girl of color in her class," Kimberly dreamed of creating a coding camp where her daughter and other girls like her would never have to feel like the "only."

Kimberly immediately started talking to friends about the dream and took her daughter to every coding event she could find where they lived in San Francisco.

She spent the next few years researching and attending coding and entrepreneurial events, all while raising her daughter and working a full-time corporate job in biotech.

The dream kept growing. After attending a panel at an entrepreneurship conference in 2011, Kimberly stayed on to talk to one of the panelists who had inspired her. She found herself saying her dream out loud to this woman—that she wanted to start a nonprofit organization called Black Girls Code.

"That's a genius idea," the woman responded. "I love it, you should go home right now and save that name

and make sure you register the domain and copyright that idea."

Kimberly did just that. A few months later she held her first six-week pilot program of Black Girls Code.

It worked, and she kept going, all while maintaining her full-time job. She felt like she had two full-time jobs, but she *loved* it. Her passion powered her through.

"I think it's about knowing yourself, knowing what drives you, and trusting yourself," she says. "And being open to changes, to trying new things, to following where your heart leads you. When you get to the right place, you'll know it, without a doubt."

But doing a job on the side of a full-time job while parenting isn't ever easy, no matter how passionate you are. When Kimberly inevitably got stuck or felt like she was on the edge of burnout, she would always "take some time" and step away.

"Stopping sometimes is so vital," she says. "A lot of time we'll just put our heads down; entrepreneurs tend to work through it and grind it out, but that often leads to burnout. So pushing past burnout is the worst thing you can do when you're really driven. Instead give yourself a little time to step back. Recalibrate. Be kind to yourself."

Stopping when she needed to allowed her to recharge. It also served as a chance to remind herself who she was apart from the work and create empty space to see what else might come.

What often came in that blank space for Kimberly was more ideas. That's how she knew she wanted to keep going, and, once she felt revived, she would get back to it.

In 2011, Kimberly left her full-time job to go all in on Black Girls Code, and by 2023, Black Girls Code had taught over thirty thousand girls. And the one it all started with, Kimberly's daughter Kai, went on to college to study computer science.

Chapter 8:

TRAGEDY

When things fall apart.

✳ DREAMING AFTER
LOSING EVERYTHING
(JAMES ARINATWE)

James Arinatwe grew up under a thatched roof in Western Uganda. He dreamed of graduating from college one day, something his mother instilled in him even though she was only alive for the first six years of his life. She was a teacher and often took him to school with her when he was very young, always teaching and encouraging him.

"My mother always said you can always dream as far as you want," he says.

She died of cancer when he was six, and then James's dad, a farmer, died of AIDS when James was only ten years old. Then he lost all three of his siblings to preventable diseases like the measles. By the time James was ten years old, he was an orphan. By the time he was ten years old, he'd lost everything.

It was tempting to give up, especially on dreams; what good was a dream in a world like this, when everything can be taken away in an instant?

And yet, James couldn't help but remember everything his mom taught him. She'd told him how she always dreamed of going to college and hoped he would go in

her place. Her dream became his, and it kept him going.

James moved in with his grandma and walked seven miles to school each day. They struggled financially, but James remembers how his grandma always shared whatever they had with kids in the neighborhood who had even less. It made young James angry at first; he thought, *We don't even have enough and you are giving what we do have away?* But through her he learned about service, and how sharing, even in the darkest of times, can be a kind of rebellion, a choice to be made when so little is in our control. His grandma always chose to share, and he noticed.

And then, James's cousin graduated from college and returned to Uganda to build the first water well for his community and an iron roof for his family's home. James was inspired. His dream grew. Now he didn't just want to graduate from college, he wanted to come back and do what his grandma and cousin were doing: share, help, make things better for his community.

But as much as he wanted this dream, James's environment pulled him in another direction. At that time in his village, many kids, especially orphans, were often lured into gangs that promised to provide a kind of family for them, as well as a way to make money and survive impossible conditions.

James joined one of these groups, but his grandmother didn't give up on him; she kept encouraging him to stay in school and reminding him about his original dream. Her love and persistence helped him step away from that group and focus again on his education, although, by that time, going to college seemed more impossible than ever.

But, following his grandma's and mother's example, James decided he didn't need a college degree to start

working toward his dream of improving his community. He could do that *now*. He started looking for ways to help and began volunteering with a local project working to bring solar energy to the nearby schools and clinics that didn't have electricity. An American couple working on the solar energy project noticed James and his commitment. They became friends, and the couple learned about his dreams. They wanted to help. They sponsored James to come back with them to Tallahassee, Florida, where he began his college education at Tallahassee Community College, the school James eventually graduated from. He was even asked to be the graduation speaker.

James went on to finish his bachelor's degree at Florida State University and then got two master's degrees, which he has used to become an influential leader in Uganda, providing access to more resources, education, and opportunity for his community and being a vocal advocate for change, even writing an op-ed for the *New York Times*.

James works to provide more opportunity where he grew up. While he knows it is a place without a lot of privilege, he is working to change that. He also believes he is one of the luckiest and most privileged people there is because, as he says, "I had a mother who loved me. I always felt like I was well off from within."

✶ GIVING YOUR DREAM BACK
(ROBYN ROSADO)

Robyn Rosado always dreamed of being a mom—ideally, a stay-at-home mom. When she was single and worked behind a cash register and would see women coming in during the middle of the day holding their babies, she felt a kind of ache inside, a deep longing.

When she got married, she told her husband her dream of becoming a stay-at-home mom; she knew it wouldn't be easy financially, but she thought he should know her biggest dream. He thought it sounded lovely, remembering fondly the days when his mom could be home with him. He wanted to try to make it happen too.

Not long after they got married, they bought a condo. Interest rates were high then and it was an expensive choice, but it was the one they thought they were supposed to make: get married, buy a place. They wanted to start a family right away, but when they looked at their budget, it was clear both of them would need to work to make ends meet.

They reassessed this now shared dream and knew they would have to make a choice. Did they want to own a home or did they want Robyn to be able to stay at home with their kids?

They chose the latter, sold the condo, and moved into a camping trailer next to Robyn's parents' house. Her husband worked a job in insurance and she got a job as a secretary in the same building so they could make it work with only one car. They planned to save money while they tried to get pregnant.

But it didn't seem to be working. Every month, Robyn threw sticks with lonely pink lines in the trash.

A year and a half later, when a close relative had a baby and Robyn came to visit, the new mother handed the newborn to Robyn and asked her to adopt the child; she wasn't ready to be a mom.

Robyn thought her dream had come true; she quit her job to take care of the baby.

But a month later, the baby's mother had a change of heart. She wanted the baby back. So Robyn gave her daughter-of-one-month back to her birth mom.

"I cried my eyes out," Robyn remembers.

A month later, she felt weird and took another pregnancy test. It was negative. But she thought maybe it was wrong. She really felt different this time. She made a doctor's appointment and requested a blood test.

She was pregnant.

"I started wearing maternity clothes right away," she laughs. "I wasn't even showing. I wanted everyone to know I was pregnant." Nine months later, she had a baby girl.

To make ends meet so she could stay at home, she and her husband sold their car, ate rice and beans, didn't buy things or go out to dinner, and never went on vacations. They both made sacrifices to make her dream come true.

"It was definitely a team dream," she says.

It was hard at times, and some days it looked like she'd need to go back to work. But then, she'd come home and find bags of baby food on the counter, or a roast in the freezer; her mom had a key to her place and would sneak things into the kitchen to help.

Eventually Robyn had another baby, a boy, and after living in the trailer for a while and saving up, they were able to buy a small home. To help pay the bills, Robyn did any job she could do *from* home, like selling things from catalogs or giving people perms in her kitchen sink. They still only had one car; her neighbor would give her a ride to the grocery store. But she was happy.

"I loved being a mom," she says, "just playing with my kids, having a little routine, walking them around the park, taking them to the pool, singing songs."

Among her most treasured memories are the days she would take her daughter outside every morning to wave goodbye to her husband as he left for work in their only car. She'd walk all the way to the end of the driveway each time, baby girl on her hip, waving.

Today, whenever her now-grown daughter drives away after a visit, she still walks down to the end of the driveway to wave.

And I wave back every time, because Robyn is my mom, and I guess I am kind of her dream come true.

✳ DREAMING AFTER THE UNTHINKABLE
(DONNA YADRICH)

Donna Yadrich's dream began in a pediatric hospital, where Donna's daughter Audrey spent the summer of her ninth grade year. One afternoon at the end of the summer, Audrey had her laptop perched on her lap as she lay on the hospital bed, like always. But then, Donna saw Audrey slam it shut and declare that social media was *stupid*.

Audrey never behaved like that, so Donna thought it was odd and asked Audrey what was wrong. Audrey explained her pain at seeing all her friends post pictures of their new school outfits, getting ready to start high school.

"There was this whole world going on that she wasn't a part of," Donna explains.

And Audrey wouldn't be returning to school anytime soon; she needed some long-term treatments. But Donna decided to buy Audrey new clothes anyway, just like she would have had her daughter been going back to school. To make them work even in the hospital, Donna modified the new clothes, creating small holes wherever tubes and other medical devices needed to pass through,

so Audrey could feel, in some small way, like her life was still moving forward.

Audrey loved being able to express herself using clothes, even if she could only wear them in the hospital. Her special shirts communicated her favorite colors, animals, and musical artists to nurses and doctors.

Tragically, later that same year, Audrey passed away.

Donna grieved. Donna still grieves. But she also dreamed. Remembering how Audrey lit up when she gave her the new clothes, and how doing that had made Donna feel during a time when she, too, felt helpless, Donna dreamed of giving other parents a similar opportunity— the chance to help their kids feel a little more like themselves, even in the hospital.

What if, she wondered, she could manufacture real clothes for kids like Audrey, giving them an option other than a hospital gown, to help combat the feeling many of them have that "they're not part of the real world anymore"?

Donna also hoped new clothes like this would help give the kids something else to talk or post about other than just what was going on with them medically.

"Kids—and adults—who are very ill," she says, "don't want to always talk about their disease and problems all the time. They want to still be a kid that likes dogs or reading books or talking about the latest movies."

This new idea seemed like one way she could give them a little piece of their lives back, but Donna didn't know *anything* about manufacturing a product. So she started by researching manufacturers and applying for grants. Through her research, she learned she would need to create a prototype to get things moving—but she didn't know how to sew.

She shared her dream at a local chamber of commerce meeting and was open with where she was stuck, telling them, "I'd like to do this, but I can't find anybody who can sew, and sew well, because this requires special machines; it's not what a traditional seamstress has in their house."

A woman in the crowd spoke up. "I know somebody who can help you."

She connected Donna with a friend of hers who had many specialty sewing machines—it was a personal hobby—and this woman was more than happy to help Donna.

"She helped me come up with amazing designs," Donna says. "It was just unbelievable. It's hard to talk about your vulnerabilities, but you have to be able to reach out and say, 'Here's where I'm stuck.'"

Donna brought the early prototypes to kids in the cancer unit of her local children's hospital to get their thoughts and feedback. She gave out surveys to the kids, their parents, and the hospital staff.

"The ratings were unbelievable," she says. "That was when I knew, *Oh my gosh, this is real*. It was my dream."

She called her project AudreySpirit.

"The same attention I gave Audrey in person, I gave to AudreySpirit," she says. "So that's how I get through. This is my baby."

✱ WHEN A DREAM SPARKS IN GRIEF
(CARLA FERNANDEZ)

When Carla Fernandez was in her twenties, her dad died suddenly from brain cancer. After that loss, she felt more alone than ever because anytime she would talk about the loss, or her dad, she was met with what she describes as a "deer-in-the-headlights" look. Nobody knew what to say.

That's when she quietly began to dream about what it would be like to have, as she puts it, "a place where the grief conversation doesn't get interrupted within three minutes; I loved talking about my dad."

Her family was grieving too, so it was hard for Carla to lean on them; they were going through their own grief process. And while they were all grieving the same person, they were each grieving a different relationship, in a unique phase in their lives. Carla wondered what it would be like to be able to talk openly about her dad and her grief, especially with people her own age who also knew what it was like to lose someone in that particular phase of life.

It started as a wish, a longing difficult to define but acutely felt. It didn't turn into a dream until she met Lennon Flowers.

Carla met Lennon when she started a new job. After getting to know her, Carla learned Lennon had also lost a parent to cancer. For the first time, Carla's loss wasn't a conversation-stopper. Instead, she and Lennon started a conversation that almost never stopped. Carla shared her wish with Lennon—this idea of a more welcoming and inviting space for young people who've dealt with loss, something more comforting than the cold metal folding chairs in sparse office buildings that Carla had encountered whenever she had tried grief support groups.

The more she talked about her idea with Lennon, the more it became a kind of dream. Carla shared what she imagined: a space that provided comfort, where you could be surrounded by people who understood, where you could talk about your losses without feeling alone or like a patient or like a person to pity. She didn't want it to feel like therapy, either. She wanted an experience that felt more like a good dinner party, the kind you leave glowing with a sense of community and perhaps the promise of a new friend.

Lennon loved and encouraged this idea, and Carla decided to try it out. She decided to throw her own kind of experimental grief dinner party.

She wasn't that nervous (aside from worrying about burning the food) because she considered the party a "mini dream," an experiment. She put the event firmly into the casual, "let's see how it goes" category and felt no pressure. She did sometimes think, *This could be the most awkward thing we ever do in our lives*, but it was only one night and she wouldn't be doing it alone. Lennon was going to help.

They both invited their friends who'd experienced grief, via emails Carla carefully crafted.

"That was actually an important part of the beginning for me," Carla says. Her dad had only been gone a few months then, and creating those invitations made her feel something she hadn't felt in a while. For the first time, she didn't feel like she was just having to be reactive, in survival mode.

"It was nice to realize that in my own dream," she says, "I could call the shots. I could create a style, a tone of voice, and create a mini world."

On the night of the party, just before everyone arrived, Carla relished looking around at the space she'd created.

"I'm not a professional or an art director or anything like that," she says, "but it was really nice to set this space up in a way that was really beautiful, to have some candles and a meal. That was definitely a part of making my dream real. Because it wasn't just about getting people in the room, it was about creating an environment that felt special and would invite out people's inner worlds: their vulnerabilities and stories and the questions they haven't asked."

And it worked. The women at that dinner party opened up to each other, and it was like nothing any of them had ever experienced before. Carla had found the community she'd been craving; it was the first time she was able to talk about her loss in a group without anyone getting uncomfortable or changing the subject.

When the dinner ended, no one wanted to leave.

"That's when I was like, *Okay, there's something going on here*," Carla says. Her dream started growing.

She didn't know exactly how it would grow or in what direction, but she and Lennon had a gut feeling that this wasn't supposed to stop after one dinner party.

They hosted more dinner parties locally over the next two years, and the positive feedback kept coming. They also added someone else to their partnership, Dara Kosberg, a woman they had worked with who had lost her mom.

Most of the attendees encouraged them to grow bigger, seek funding, and expand to other cities and states. Dara, as Chief Community Builder, helped them expand, but Carla was nervous.

"It was a personal and very private project in many ways," she says. "It was hard to make that leap."

But eventually the richness of the experiences from these dinner parties felt too special to keep to herself. She did want more people to have that experience, and the responses she was getting showed her that maybe there were a lot of people out there like her who craved something that wasn't about "getting over grief," but about leaning in to it, living with it.

At the same time, not everyone was encouraging.

"Some people," she says, "were like, 'You all are building an organization and are going to spend all of your time thinking about sad stuff? Do you really want to be dedicating time to this?'"

The negative feedback was always hard, and Carla would wonder sometimes if those people were right. But every dinner party made her feel otherwise, especially the unexpected beauty that came from the conversations.

"We're missing out on a lot of wisdom because we're so hesitant to talk about the way we're all going to end

up," Carla says. "We have so much to learn about what it means to be alive and what it means to die."

Carla, Lennon, and Dara decided to start an Indiegogo campaign to help raise funds for expansion. Carla was still terrified to put such a personal dream out there for the world to see and judge, but seeing other dreamers online gave her courage.

"I would look around at so many people on the internet who were working on making their dream happen," she says. "I told myself, *What do you think makes you so special?* Not in a demeaning way but like, *This is great; this is the moment we're living in where you can DIY this kind of thing, and this is how things get off the ground.* It was a little bit of, *Don't take yourself so seriously, and just take a leap.*"

While the content of her dream dealt with serious subjects, Carla realized turning it into a *thing* didn't have to be so serious. This, too, could be an experiment—a "let's see how it goes" kind of thing.

Whether they met their fundraising goal, whether it turned into anything beyond what it already was, she knew nothing could change what had already happened, the value it added, and, at the very least, the way it made her feel when she created those first invitations.

When the Indiegogo campaign went live, they raised money far beyond their goal, allowing the Dinner Party to launch. Carla, Lennon, and Donna were even featured in O, *The Oprah Magazine*.

Carla's dream began with a single dinner during the worst year of her life, and it started something that is now in over one hundred cities.

✴ LOSING A DREAM
(MAUREEN CRAWFORD)

Maureen dreamed of having a family and was elated when she and her husband got pregnant.

The baby shower was full of family and baby toys and joy. Afterward, mobiles were hung, books were shelved, socks were folded, the crib assembled. Everything was ready for their baby's January due date.

But on the afternoon of December 30, something felt off to Maureen. Her baby, an avid rib-kicker, wasn't kicking as usual. Things seemed a little quiet, but Maureen wasn't too worried; her baby was probably sleeping. She wasn't sure if she should call the doctor on a Sunday night or wait until the morning, but then her husband, Michael, came home from the grocery store and said he had run into their ob-gyn. That prompted Maureen to tell him she thought it was weird she hadn't felt as much movement today. She decided to call the doctor that night, and they advised her to come into the hospital to get checked out just to be on the safe side, since she was so close to her due date.

Maureen walked into the hospital with Michael at her side, and was examined by a nurse.

"She moved the ultrasound around and nothing was happening," Maureen remembers. "I thought, *This is*

weird. Then she kept going, and I felt a shift in energy, that maybe something was wrong."

The nurse turned to page the doctor, and Maureen says that's when it hit her. "I thought, *She can't tell me. She has to have the doctor say it.* And so I said, 'Is there a heartbeat?' and she said, 'I'm so sorry . . .'"

The heartbeat was gone. Her baby had died.

And now, the doctor explained, they were going to need to admit Maureen immediately so she could give birth. "You've got to be f*ing kidding me," Maureen told them.

"I don't know why it was such a shock to me that I would have to go into labor," she says. "But at the time it just didn't seem fair, like, *Hey, your baby died and now we're going to induce you.* I was pissed. It seemed so cruel, and I was scared to go into labor. I just lost a baby, and now I have to go do this right *now?*"

Maureen was a collegiate soccer player for Michigan State University, where she was honored as a Spartan Keyholder, a title that has only been given to a small group of people in the school's history—people who represent a Spartan, a warrior. Maureen was always that kind of person, the kind who pushed through, who always believed she could get through anything and come out on the other side, and she always did.

But now, she didn't think she could get through *this.*

Just before she was given a pill to induce labor, a nurse looked over Maureen's file and noticed that if they induced her now, her baby would likely be born tomorrow, December 31, which the nurse noticed was also Maureen's birthday. She bent down by Maureen's bedside and kindly shared that Maureen didn't have to

do this right now; she *could* wait a little longer if she didn't want her birthday forever associated with this.

Maureen was moved by this woman's thoughtfulness, but at that moment she couldn't imagine going home knowing her baby wasn't alive. She was resolved and said to go ahead.

And then she felt the terror.

"It was the only moment in my life," she says, "where I thought, *I don't know if I can do this*."

And she's not talking about self-doubt. She's talking about the overwhelming belief that she truly *couldn't* survive this. That she truly was not physically or mentally or emotionally able to *do* what she was being told she had to do. In that moment, it felt like there was truly no way this impossible task could take place, and Maureen let herself feel the impossibility of it.

And then, another thought immediately rushed to her: "*I'm f*ing doing this sh*t*." She remembers coaching herself as she looked out the window into the dark parking lot, after she'd stepped away for a moment to be alone. "*I have no choice. I have to do this*."

Maureen was induced. A nurse quickly placed a teardrop sticker outside of her door to indicate what kind of labor this was, lest anyone walk in with a smile or a misplaced "congratulations."

Maureen gave birth to Hadley Mae Crawford on December 31, 2012.

She did the thing she thought she could not do. And on her birthday, now their birthday, Maureen held her daughter.

That day her childhood best friend, Erin, who'd been at most of Maureen's birthdays, came to visit the

hospital, and Maureen asked her to bring a birthday cake. Erin showed up with a cake that said, in purple frosting, *Happy Birthday Maureen and Hadley.*

"We take our birthdays for granted," Maureen says. "It's our *birth* day. That's crazy. We were born. And we lived."

After Hadley was born, Maureen and Michael were allowed to take all the time they needed with her, and they took it. Maureen wanted time alone with her and wanted Michael to have that time as well. Maureen held her, cried with her, and sang to her.

And then Maureen knew it was time and said to Michael, "Okay, we have to let her go."

And Michael said, "We get to."

"In that moment," says Maureen, "I knew he wasn't saying how great it was that we got to let her go, but he was saying we were lucky to have her, that she existed; she was ours and always would be and yeah it sucked but we got to love this little one and we will always get to be her parents.

"When they came in to take her away," Maureen says, "it was the worst moment of my life."

Maureen made it through labor, but she says signing Hadley's death certificate was the hardest moment of her life.

"There are times where you sign your name out of great pride and joy," she says, "like when I would sign autographs for little girls at our soccer games. But this time I had to sign my name because she died. She wasn't given a birth certificate. Only a death certificate. I had to sign my name to release her, to let her go, and it felt like I was saying that I was never a mom.

"Then they put her in a bassinet on rollers and they just wheeled her down the hall."

Before Maureen went home, she asked her friend Erin to clear out some of the things in the house that were waiting for Hadley to come home—the clean bottles in the kitchen, the baby clothes that were laid out. Erin and her husband, Tim, bought bins and went to Maureen's house to put everything away like she asked.

"But then as we were driving home," Maureen remembers, "I had a different feeling. I remember thinking, *I don't want her mobile to be gone. I don't want her crib put away.*"

She wanted to come home to whatever fragments were still left of this dream, proof that it was real, that Hadley was real, that they tried, and that they loved, however briefly.

"All I could think when we drove home from the hospital," she says, "was, *If the mobile is not there, I'm going to f*ing lose my sh*t.* It was the only thing that mattered to me."

The first time Maureen cries when telling this story is when she talks about signing the death certificate. The second is when she talks about the mobile; it was still there when she got home.

"Over the next few days," she says, "I took everything back out of the bins. I refolded things and put them away. I needed to still feel them. So often we try to take away the pain for ourselves and others, but feeling it all was important to me. I needed to grieve it fully."

A few weeks later, Maureen woke up in the middle of the night, frantically searching the covers in a panic

looking for her baby. It took a few heart-wrenching seconds for her brain to catch up with her hormones and remind her of what had happened.

The doctors were never able to figure out why Hadley died. Maureen had done nothing wrong. They even weighed Hadley's heart; everything looked fine.

Maureen was not fine. She spent the next few weeks of her life grieving and surviving. Maureen tells me how she used to have a "six list," a concept she learned from a conference that she used when she had her own business, where you write down six big income-generating things you'll do that day. Maureen says her "six list" went from things like "email" and "client meeting" to "shower, cry, food."

She and her husband spent long evenings in front of the TV. Every day was just a day trying to get by, trying to learn how in the world to keep going alongside this kind of pain.

As time went on, the grief remained, but the weight of it seemed to lighten. But Maureen didn't feel relieved. The farther she felt from the pain, the more she panicked, questioning, "Was this real? Was this really even a big deal?"

Around that time, Hadley's memorial service took place, at a cemetery in Lawrence, Kansas. Hadley's headstone sits at the top of a hill, in an area for children designed in the shape of a teardrop. When Maureen's brother hugged her the day of the memorial, she let out what she describes as her first real wail.

"It was such a loud sound," she says. "My brother was able to hold me, and I was able to really be in that moment of 'I am not okay.'"

Being in that moment, she says, was a gift. It allowed her to feel everything else she'd been pushing away.

"I felt the disappointment of a dream ending—and shame," she says. "Which doesn't make sense; I did everything I needed to do. There was nothing else I could've done. But still you feel like you did something wrong, even when you didn't."

But, as Maureen remembers the day her brother held her, she thinks about how often the people we are most afraid of letting down are the people who will hold us as we grieve the dream we tried for that didn't work out. Maureen tells me how once she found her sister in Hadley's partially intact nursery, her fingers pressed against Hadley's fingerprints on a certificate, crying. Maureen saw then how even unrealized dreams impact people, and that grieving together isn't a sign that mistakes were made; for Maureen, it's a welcome reminder that *it was real.* All of it.

The people who cried with her helped her remember that this hurt so much because of how big she dreamed, how hard she tried, and that if she wanted, the part of her that cared that much didn't have to die too.

Before Maureen was pregnant with Hadley, she'd gotten a small tattoo on her wrist, one word: *Hope.* After Hadley, Maureen got her second tattoo, the coordinates of Hadley's headstone, inked just under her right rib, where Hadley used to kick.

After losing Hadley, Maureen returned to her work as a high school girls' soccer coach. During her first game back, the girls on the team took off their jackets to reveal the special black armbands they'd made with Hadley's name on them. As the girls ran onto the field,

Maureen wept, but this time the tears felt different. For the first time, she didn't feel like she was crying for what she'd lost, but for what she'd gained.

"I always thought I would get to see my kiddo play," she says, "and at that point I didn't know if I would ever be able to have kids, if that was ever going to happen for us. When things die, they die, right? And yet it was like Hadley was on the soccer field, part of a game I loved. This was not how I expected it to go, but what a gift. Somehow Hadley's life touched people in some really big ways. Sometimes when I worry if I'm doing enough I think, *She didn't even have to say anything and she made an impact.* She didn't even have to do anything and her life meant so much. Hadley never even said a word, and she has impacted my world in a massive way."

One of the greatest gifts Maureen says Hadley gave her was the knowledge that she has tremendous strength to handle anything: "I've learned to loosen my grip. No matter what happens, I know now I'll be okay."

Maureen eventually got pregnant again, and today, she has two sons. When her oldest was a toddler he'd often say, "I had a sister but she died," and Maureen loved that. "I think we get so scared of dying, but I think if we're scared of dying we get scared of living."

Today, Maureen's "Hope" tattoo looks a little different. Now, the H is underlined, for Hadley.

✳ DREAMING IN A WORLD
THAT'S AGAINST YOU
(TRABIAN SHORTERS)

Trabian Shorters grew up in Pontiac, Michigan in the late 1970s. What he remembers most is the joy he felt whenever he'd see people do break-dancing battles on the streets, dancing on flattened cardboard.

But by the mid-1980s, it seemed like everything in his town had changed. The auto industry collapsed, factories shut down, and people lost jobs that would never return.

"It was mass depression," he says. "We watched our parents not know what the future held and not have the skills to readjust because generations had been doing that work. Dimness set into their eyes."

Then, he says, "this new drug hit the streets called crack."

By the early 1990s, a new phrase was coined to describe young Black men: super predators. Trabian remembers seeing a professor on TV talking about super predators—defined as "children growing up fatherless, jobless, and Godless"—and how the "data" showed that their numbers were growing.

"They took these rare violent occurrences," Trabian explains, "and made them seem common, like there was this whole growing threat."

At the time, Trabian attended Cranbrook, a private boarding school six miles from his neighborhood; he lived at the school nine months out of the year and spent the summers living with his grandparents. His mother, he explains, had him when she was a teenager and worked very hard to provide for him and his siblings. She was the one who ultimately got him into the Horizons Upward Bound program, where he earned a full scholarship to Cranbrook.

As a teenager, Trabian often felt like he lived in two different worlds. At his elite college prep school, cobblestone walls were covered with ivy and teachers had PhDs. Six miles away, his town was, as he says, "going through hell."

"I watched a community collapse," he says of that time, "and I watched the outside world blame young people for that collapse."

Resources and opportunities were dwindling, and the people in Trabian's community were scared. But when they watched the news, it seemed like the rest of the world wasn't scared *for* them but scared *of* them.

The sense of community Trabian grew up with dissipated, as did hope.

"Once you give up hope," he says, "all types of demons can enter."

The break-dancing on the street stopped. Some people started carrying weapons. For the first time in Trabian's life, his neighborhood became a dangerous place.

"I watched people die, physically and spiritually," he says, "but in reverse order; usually the spirit dies first."

Too many of his friends started to feel like they now had only two choices in life: "either become victims or predators."

It felt like life or death, because it was.

"I remember in the height of the worst times," he says, "if some guys lived to be twenty-one that was cause for literal celebration; there were parties to celebrate Black boys making it out of their teens, and I look back now and think how crazy that is. It was traumatizing."

But when Trabian tried to explain what was happening to people at his private school, they didn't want to believe him. No one understood, nor did it seem like anyone wanted to even try.

"I realized people who haven't lived through this stuff don't actually like to hear these stories," he says. "It makes them feel bad. I used to think people cared, and they do, but what I didn't realize is that these stories are so heavy that people feel burdened by them, especially if they feel like they can't help."

Trabian knew what he'd experienced was difficult, but he didn't know how intense and horrifying it really was until he saw it reflected in his classmates' eyes.

"I realized these true stories, my life experience, were so difficult that even hearing about it for other people was too much for them to bear," he says. "So, you can imagine what it's like living through them."

He credits his mom and grandparents for helping him see that there were so many more options beyond victim or predator. It could begin, they said, with faith.

But before he could accept that kind of hope, he needed to acknowledge and process all he'd seen and endured.

"It was hell," he shares. "Thousands of people died while we were growing up and, even worse than that, we got a very clear signal that society not only didn't care but blamed us for being in hell."

Trabian marveled at his grandfather, a pastor, who would listen to Trabian talk for hours about whatever problems or feelings he had but would never give advice. Instead, his grandfather would ask questions. Trabian's answers to those wise questions always provided clarity and helped him see that he had options.

Having such a loving man in his life, even in the midst of a hostile world and neighborhood, made it clear to him that he did not have to accept the world's ugly, one-dimensional narrative for him. His grandpa taught him that even in the face of injustice and tragedy, he could still choose hope and love for himself and for his community.

"People want community," he says, "but they also need it. We need it on a visceral level. People of all races and genders want to belong to a group that feels nurturing, where they have a sense of identity and a role and a purpose and friendship." *If everybody wants that*, he started thinking, *how do we get to a place where everyone can have it?*

Trabian went to college with this question in mind: "How do you form communities?" If he could find the answer, his dream was to foster a more positive sense of community wherever he could.

The answer came to him in college—not from a textbook but a sit-in. One afternoon, a group of a dozen or so students staged a sit-in to protest years of mistreatment of Black students on campus and in the campus town. Word spread and more students joined in, including Trabian. Everyone involved was threatened with expulsion, flunking, or even jail. But they stayed together, over three hundred people, for eight days and nights.

"We were forced to form a community inside the sit-in," Trabian says, "because there were three hundred people but only two bathrooms." He laughs, but he's also serious.

"We had to learn how to get along, and the support that we got outside just grew day after day. When it was all over, we got all of our demands met, and there was just this sense that we were connected."

From that sit-in, Trabian learned that while often, as he says, "people are disinterested and they couldn't care less and they sort of isolate those who are suffering by not thinking about them, that can all change in a heartbeat. I've seen it over and over again since then."

His dream felt stronger than ever; he wanted to start an organization that would help create that sense of community *and* continue the kind of change he was starting to see. He hoped he could make change in whatever way he could, one story, one person, one connection at a time.

He'd also seen what happened when people gave up hope; he wanted to change that. In 2013, Trabian started the BMe Community, an award-winning network of leaders who invest in aspiring communities, training organizations in matters of diversity, equity, and inclusion, and running fellowships to support the dreams of Black leaders in the United States.

To date, their members control billions of dollars dedicated to helping Black people and all people to live, own, vote, and excel in life without stigma. They also teach social impact leaders in business and philanthropy to do the same. They share stories of incredible Black men, such as in their *New York Times* best-selling book,

Reach: 40 Black Men Speak on Living, Leading, and Succeeding, featuring stories of people like John Legend, Russell Simmons, Isiah Thomas, Bill T. Jones, and Louis Gossett, Jr.

When Trabian thinks about everything that has happened in his life, he's most grateful for his grandpa and the ways he showed Trabian how being who you are even in a world that seems to hate who you are can make all the difference.

"Find somebody who represents that hope," Trabian says, "or who represents where you want to go, and hold on to them."

✸ WHAT COMING IN LAST MEANS
(AMY DOWNS)

Amy Downs had two big dreams: to get healthy, and to have a child. Every Monday morning she woke up and hoped *this* would finally be the week she would begin working toward those dreams.

But every Friday, she felt like a failure because nothing had changed.

But everything did change on a Wednesday: April 19, 1995. That day, Amy arrived to work like always, and sat in her ergonomic chair to work alongside her friends and coworkers. But at 9:02 a.m. that day, there was an explosion.

Crashing.

Cubicles on fire.

Glass windows shattering.

Then, Amy blacked out.

When she opened her eyes, she noticed she wasn't in her office anymore. She was trapped somewhere beneath the rubble of the Alfred P. Murrah Federal Building. The Oklahoma City bombing had just occurred.

Amy didn't know then that 168 people would die from that explosion, including nineteen children, but she

was sure that whatever the death toll was going to be, she would be one of those numbers.

"I thought my life was over," she says. "I thought about all those Mondays and January firsts that had come and gone and how I hadn't done anything with my life. I was hit with the reality and the magnitude of having lived my life and not accomplished what I really wanted."

Amy was trapped for six-and-a-half hours, and for those six-and-a-half hours all she thought about was how she was going to die without having ever done the things that mattered most to her.

"I thought about everything in my life I didn't do," she says. "I didn't have a degree; I had flunked out of college; I never had a child. There were so many things I had never experienced."

When, after six-and-a-half hours, Amy was rescued from the ruins, she was forever changed.

Once she recovered from her injuries, she was compelled again to start working on her dreams. But this time, she didn't wait for Monday. This time, she focused on starting today, doing whatever small step she could right where she was.

That mindset led to her going back to school and eventually getting a master's degree. She also had a son.

"It was like systematically I was trying to almost check them all off my list," she says. "I thought, *I don't want to die again and not have done these things I wanted to have done.*"

But there was still one thing on Amy's new bucket list that was looming. She really wanted to get healthier; at the time doctors had told her she was two hundred

pounds overweight and that if she didn't make some changes, her life span could be shortened.

"Going back to college, I mean that's difficult, that's hard," she says, "but it's *doable*. But things like kicking a drug habit, quitting smoking, or losing a significant amount of weight for health reasons are a whole other issue because somehow you've gotten yourself imprisoned but now you're trying to break free. You feel like you can't really live your life because you're chained to this problem."

After a lot of research and consultations with multiple doctors, Amy decided to get bariatric surgery. But the scariest thing she did came after she recovered from surgery—she went to a gym.

She was terrified to walk into a gym, but she did, and went every day before work, at 5:00 a.m. Then Amy's sister, noticing that she was becoming more active, invited her to ride bikes with her, which planted the seeds for what would soon become Amy's biggest and most challenging dream yet.

"I loved it," Amy says of riding bikes with her sister. "It was so much fun. And I will never forget when we went out to ride around Lake Hefner. There were all these people out there running and cycling, on skateboards and rollerblades, and I was like, *Is this a secret society? What is this?* I was never exposed to anything healthy. I didn't even know we had a trail system. I didn't even know anything like this *existed*."

Amy was blown away by the fun and community that came with living an active lifestyle. She started cycling all the time, meeting new people, loving it.

Not too long after, someone from the Oklahoma City National Memorial Marathon, which was held

every year to honor the people killed in the Oklahoma City Bombing, asked Amy to come and help hand out medals. She said yes.

"I'm passing out medals," she says, "I am seeing all these people cross the finish line, and I can't even explain the emotion. You're seeing old people, young people, people with one leg, all crossing the finish line. I was moved by it and told a couple of friends, 'Next year I'm going to run in honor of my friends that were killed. If all these people can do it, I can do it.'"

Amy was determined, but once she started to look into what it would take to actually *train* for a marathon, she was terrified.

"The finish line looks wonderful," she says, remembering the day she declared her new dream, "so of course you want to do it. But I had never run before in my life."

But that glimpse of what the finish line could be gave Amy enough courage to sign up for marathon training. On the first day, she learned she couldn't run for more than ten seconds at a time without needing to walk and recover.

"I remember thinking, *Oh my gosh, my head is so screwed up! Why did I say I would do this? There has got to be a better way to honor my friends. This is not good.*"

But despite the doubt, she still wanted to do it. To help her endure, she invited friends to train with her.

"I sucked a bunch of other people into my craziness," she laughs. "It's always easier to stick to a goal if you can pull other people in with you."

With the help of her friends, Amy kept running. She also kept cycling with her sister. Because of that, someone told her that if she learned to swim, she could do a

triathlon one day. The idea of being a triathlete thrilled her, so Amy hired a good swim coach.

"I didn't know how to swim," she explains. "I'd never swum before in my life. I showed up to my first training session with a skirt on because I didn't know about athletic swimwear yet. The coach took one look at me, and I could tell he had written me off right away because he only coached really serious athletes."

But Amy was more serious than he knew.

"I did everything he said and I kept trying," she says.

It wasn't easy. At times it was even traumatic.

"The first time I got in the pool I cried the whole way home in my car. Swimming for the first time," she explains, "felt just like being buried alive in the bombing." But she got back in the pool the next day, and eventually learned how to swim.

With the Oklahoma marathon still months away, Amy started competing in smaller events for practice. But during a run and swim event called a "Splash 'n Dash," a storm rolled in, causing waves in the open lake. Amy panicked.

"I couldn't even put my head in the water," she remembers. "I literally dog-paddled. The director of the event, a triathlete, came over on a speedboat and followed me." She could see his look of concern, how he was ready to save her at a moment's notice.

"I knew I was failing," she says. "I couldn't put my head in the water. I couldn't even do what I had been training to do. I just couldn't do it. I dog-paddled to the end, though. I went on my run. But I was so far behind. I came in last."

By the time Amy crossed the finish line, everyone else had already gone home.

"I just remember thinking, *What am I even doing here? Why am I even here?* There was nothing great about it. There was no, *Oh, here's a good story.* No. It just sucked. It was just depressing. I just went home."

But the next morning, she found herself thinking, *Okay, I just have to figure out how to keep going and not let this stop me.*

"I just kept at it."

Her next event was a sprint triathlon. She remembers looking at everyone in front of her. "I was coming in last, again."

But this time, she tried to shift her perspective: "I just kept telling myself, *Look at me, I'm at the back of a pack of athletes! I'm middle-aged. I have never done anything like this and I'm associating with these people. I'm part of this group.*"

Instead of thinking about her placement or ranking, she started relishing in the idea of being a part of something she'd dreamed about.

"I may be at the back," she says of her mentality, "but I am beating that person who's on the couch thinking, *Maybe Monday I will start.* That was me. I'm beating myself—that is who I'm beating."

She reminded herself too that her dream was never to become a *first-place* triathlete. The dream was simply to *become* a triathlete. And here she was, "part of this group" of triathletes, a dream come true.

But there was still one more important race to run, the full marathon in honor of the friends she had lost in the bombing.

Amy hired a running coach to help her prepare for the full marathon and trained every day. She got better.

A lot better. Her coach told her he thought she could probably run the marathon in five hours.

But two weeks before the marathon, while cycling, another cyclist crashed into Amy. She blacked out, then woke up in an ambulance with an injured knee and a concussion.

Two weeks later, her doctor said that as long as her knee was bandaged, she was cleared to run. So she showed up to the race, and the start was everything she'd dreamed.

"When you start a marathon, everybody is cheering for you," she says. But, she explains, by the time you're in the middle, "the crowds disappear. Those middle miles are all you."

Amy kept going, but then her knee started to bleed through her bandage. The power walkers started passing her. She started slowing, walking, then limping. *I can't do this anymore*, she thought.

Once again, the medics hovered close by, ready to help her get off the course.

"Just tape my knee up," she told them. They did, and she kept limping along.

But then she started crying. *I'm going to have to quit*, she thought. She thought about the TV interview she'd done that morning. "I felt responsible. I told people I was going to do this."

But then she said to herself, *Everybody knows about the cycling wreck. Nobody will blame me. They'll understand*. She was calling it. It was time to quit.

"Then," she says, "this girl rides up next to me out of nowhere. I recognize her as someone I'd met in the cycling community a while back. She wasn't running in

the marathon—she'd just had a baby—but here she is on this bike wearing blue jeans, and saying, 'Amy, you're going to do this!' She started encouraging me, and then asked, 'What do you need?'"

Amy asked for some pain reliever and her friend flagged down a medic to bring her some pills and water. Amy took them and kept going, but still crying, thinking, *Everything is screwed up. There's no way I'm going to make that five-hour goal. I've failed. Everything is going wrong. Here I am, in my forties, I've just gone through a divorce. This race feels just like my life. I've planned everything out exactly. I got a coach, I did everything I was supposed to do, and now look—I can't even run. Nothing has turned out like it's supposed to.*

But then, a song Amy loved started playing on the loudspeakers, and she started walking a little faster. Then she felt good enough to jog. *I know everything's messed up*, she thought, *I know I'm not making the time I want. But I'm just gonna do it anyway.*

She kept going, but as she got closer to the finish line, she was devastated. It was clear that the event was shutting down. There would be no one there to see her finish, no one there to give her a medal. But she kept going.

And once the actual finish line was in sight, Amy was confused.

She saw someone there, waiting for her.

It was the woman who had won the race hours earlier.

"She'd already had time to win, get her medal, go get groceries, eat, shower, and then come back to the finish line," Amy laughs. "But she was one of the people encouraging me at the start of the race. And here she was, waiting for me at the end."

As Amy got closer, she saw that the first-place runner wasn't the only person there. Her running coach was there too. So were all of her cycling friends.

She crossed the finish line just as it was getting torn down. She was the only runner left, and she came in last place.

But her running coach looked into her eyes and said, "Athlete, look at the time. What does it say?"

"I looked at the board," she says, "and it said 6:30; I was buried alive for exactly that amount of time. It was not the finish line I planned, but I finished, and with all of these special people."

✳ DREAMING UNTIL THE END
(SCOTT MCKENZIE)

Scott McKenzie was kind of a celebrity in Orlando, Florida, a longtime radio host known for his kindness and infectious joy, qualities that helped a lot of people cope with their commutes.

So when Scott got diagnosed with non-Hodgkin's lymphoma, it was tough for everyone. He hated being off the air for treatments, and driving I-4 to work wasn't the same for the people in Central Florida who had listened to him every day; I'd listened to him almost my entire life. Everyone missed him when he wasn't on the air, but everyone of course sent their well wishes and hoped he would get better soon.

Sometimes, at Scott's request, the station would set up equipment at home so he could broadcast from his daughter's bedroom when he wasn't well enough to be at the station.

I'm sure they encouraged him to take as much time off as he needed, but nothing made Scott happier (aside from his beloved wife and daughter) than hanging out with his cohosts on the radio.

Scott fought the disease on and off for seven years, and went into two remissions. When he was in remission, he would joyfully go back to work as usual.

But then, during a routine checkup, he learned that the cancer was back and worse than ever. He traveled the country to undergo the best possible treatments, but after it was clear they weren't going to work, Scott headed back to Florida, and hospice was called.

Scott was still well enough to write, and he wrote a blog post on the radio's website as a way to talk to everyone and give them an update. In that post, he shared how strange it felt to have hospice at your house, knowing it was there for you.

He thanked everyone for letting him spend their mornings with them, and then, he ended his final blog post with a dream. He wrote how he still, from his hospice bed, dreamed of returning to work, dreamed of laughing in front of microphones with the people he loved.

That dream did not come true. Scott died shortly after, on August 11, 2015.

I had listened to Scott most mornings and had met him in person when I was fresh out of college. I'd been asked to give a speech at a scholarship fundraiser for the community college I'd attended; it was the first speech I'd ever given for a big dinner like that, and I was so nervous. But afterward, Scott and his wife sought me out and encouraged me. Coming from him, it meant everything. We stayed in touch, and I became friends with his wife and daughter. I was devastated for all of them when I heard the cancer was back.

I read Scott's final blog post during one of the times when I was seriously thinking about giving up on this book. I was in a dark place, and all I could see were all the dreams that *didn't* come true. It felt selfish to dream, to write about dreams, when people like Scott couldn't

dream anymore, when so many dreams are stripped away every day.

I did stop working on the book for a while.

But then, I couldn't get Scott's writing out of my head, how he wrote out another dream even as his own body was failing, even with hospice at his side, even possibly knowing that this last dream would never come true. But he wrote it down anyway, as if he were embracing every bit of life while he still could, as if he knew that the very act of dreaming a dream, and sharing a dream, regardless of the outcome, is simply one of the privileges of being alive.

Chapter 9:

PATIENCE

How to endure.

✳ WHEN YOUR DREAM JOB ISN'T HIRING
(KIM KAUPE)

Kim Kaupe's favorite things in her teenage bedroom were the stacks of magazines she piled up, and she dreamed of working in magazine publishing one day. And, because one of her family friends moved to New York to work for *Teen People* in the 1990s, working at a magazine actually seemed possible to Kim. Once it seemed possible, it was *all* she wanted to do.

"I was laser focused," she says. "It was kind of bizarre. I never really wavered. It was magazines or nothing."

She read the fine print on every magazine issue she could get her hands on, entered every magazine contest, and applied to be a "trendspotter," someone who filled out surveys the magazines sent out.

As soon as she was old enough, Kim called the local magazine in her hometown, the *Palm Beach Illustrated*, and said, "I will literally do anything, make copies, lick postage, whatever it takes. I just really, really, *really* want to intern for you."

They said yes, and from then on, Kim stayed intensely focused and proactive, interning at a new publication every summer while in high school, and then securing

an internship in New York during college. She couldn't wait to graduate and start working full time. But she graduated in May 2008, during a recession, and no one was hiring. Still, she'd kept every business card she'd collected during her years of internships. She emailed everyone she knew, including her family friend. But no one could help. Magazines were contracting, reducing staff, and refocusing their efforts toward digital content.

No matter how much she tried, Kim couldn't get a job in the magazine publishing industry. Everyone around her kept prodding her to let go of this dream, to move on, to try something else. But she wasn't ready to let go.

"I think what kept me going," she says, "was the thought that if I didn't try my hardest, didn't try with every single ounce of my being, I would regret it."

She didn't want to ever feel like if she'd just tried *one* more time she could have made it happen.

"Obviously there are things in life that you try for and sometimes it's not in the cards," she says. But she says she wasn't ready to accept that until she *truly* knew she'd given it everything she had, and she just didn't feel like she'd done that yet.

She gave herself just one more month to try.

By the end of that month, she was offered a contract position as a marketing coordinator at *Brides* magazine. It wasn't a full-time job, but Kim was elated; this would give her a chance to get her foot in the door of her dreams.

She took the job. She smiled when she got her business cards in the mail, with the magazine's brand embossed on the front. It may not have been the full-time magazine job she was hoping for, but she was glad she didn't give

up too soon, and hoped that this small dream come true would only be the beginning. And it was. Kim went on to cofound a multimillion dollar magazine-inspired startup that was featured on *Shark Tank*.

✱ WHEN YOU FEEL LEFT BEHIND
(JANE THOMPSON)

When Jane Thompson had her first son, she was daunted by how impossible it felt at times to raise him and work full time.

"I felt I should be able to do this," she says. "I should be able to raise my children and go to work and be a success; it must be my fault that I can't do this."

But the more she learned about the history of women and work, the more she realized it *wasn't* her fault that it was so hard. She then worried about how many other women were blaming themselves when really the problem was a system that was not set up to support them.

Jane dreamed of writing a book one day that would deconstruct how and why it was so unfairly difficult for women to both work and raise kids, a book that would also propose societal and structural changes to support them. Jane pursued a PhD in women's history at the University of Toronto and started making plans for her book.

But just as she was finishing her degree, someone else achieved her dream. A friend of hers wrote the book Jane was dreaming of writing: *Ending the Mother War: Starting the Workplace Revolution.*

"It was a fantastic book," Jane says. She was happy for her friend, and believed in the content. But secretly, she was also devastated. "I was rocked to my core," she says. "I don't normally think of myself as a competitive person. But I realized she wrote the book I wanted to have written."

Jane considered giving up on her dream now that someone else had already done it. But she couldn't shake the feeling that her jealousy was something to pay attention to, that maybe it wasn't a sign that someone had "taken" her dream, but a sign that she still cared a lot about this and that maybe there was still something only she could do.

What if there was still room for her book too?

The more she thought about the issues she wanted to write about, the more she realized she still did have a book in her head that would be different from her friend's because it would be from *her* perspective.

Writing a book was still daunting, though, and Jane was tempted to stop every time she thought, *Who are you to write this?* But she kept going anyway, writing down every tiny idea she had for her book.

"It was a slow process," she explains, "partly because I had other things going on and partly because of writer's block, but I didn't worry about the speed. I thought moving forward was better than not moving at all."

When she felt stuck, she would always turn to books, like *The Artist's Way* by Julia Cameron. Jane also tried to remind herself that feeling stuck was a normal part of doing hard things.

"Some stages are going to feel really hard. That doesn't mean you are on the wrong path," she says, "it just means it's hard. You just need to find how to

get through it and find what you need. You can move a mountain if you do it pebble by pebble."

That mentality helped Jane a lot because writing her book was taking *significantly* longer than she had thought it would. It was especially tough when even more people she knew were publishing their books. She started to feel behind. But instead of letting that stop her, she decided to reframe what seemed like a disadvantage into an advantage.

"I'm smart, but I'm not fast," she explains. "But I decided there is no point spending time beating myself up about not being fast. I think about things slowly, but that is also a value I bring."

Jane finished her book on her own timeline.

But even once it was finally done, she couldn't find a publisher. She kept getting rejected over and over again. It seemed like, after all that, her book still wouldn't see the light of day.

But then, she thought, what if having a publisher wasn't the only way to make her dream come true?

"I went along thinking the only legitimate way to get a book published was to have a publisher take it, and that signified a 'good' book," she says. But then she noticed a lot of people she really respected were self-publishing. Maybe this final barrier was only in her head, and the good news about that was she could do something about it.

Jane self-published her book, *Resilient Woman: Weaving Together Work, Family, and Self*, when she was fifty-three years old. It took her thirteen years.

"Thirteen years is a long time to write a book," she says, "but if I'd decided that was too long, I would still be fifty-three, but with no book."

✳ WHAT TO DO WHEN YOU'RE WAITING
(CHERESSE THORNHILL)

In high school, Cheresse Thornhill couldn't afford the Jordans she saw on TV, but she could draw them. She dreamed of designing shoes for a living one day, even writing that dream in her artist statement, something every student who attended DASH, an arts school in Miami, was asked to complete.

Throughout high school, Cheresse spent thirty hours each week drawing. After high school, she attended the College of Creative Studies in Detroit. During her sophomore year, a Nike recruiter gave a presentation. Cheresse waited around until everyone else had left and then approached the recruiter and shared her dream of designing shoes one day. The recruiter gave Cheresse her business card, and they kept in touch.

A year later, Cheresse emailed the recruiter her portfolio in hopes of landing an internship with Nike. Then, she waited (and hoped) to hear something back.

The waiting, Cheresse says, was the hardest part. Especially because her friends and family knew she'd sent her portfolio to her dream job.

"Have you heard back yet?" they'd keep asking.

They meant well, but when Cheresse kept having to say no, she hadn't heard back yet, she started to doubt that she'd *ever* hear back.

"You start doubting yourself and losing confidence when you're in a state of waiting," she says.

When Cheresse is in a season of waiting she tries to focus on what she can control, especially, as she says, "making the connections that I need to make, and making sure my work really and truly is the best that I can do. A lot of things are outside of our control. All we can really do is prepare ourselves."

Once she knows she's done her part, she tries to let go and have faith.

Eventually, the Nike recruiter did get back to Cheresse, and she got her dream internship, and then, her dream job with Nike. But, when her dream came true was when she felt the most lost.

"I didn't really believe that it was going to happen," she says. "I think that a lot of times when we write our dreams down we never actually think it's going to happen, so we don't actually see past it. I think that's what happened for me my first year at Nike. You're kind of in a state of starting over."

When she started at Nike, she was one of twelve thousand employees and about eight hundred designers. The size of the place was daunting, but she tried to make everything feel smaller by focusing on what she loved most, which was the Jordan brand. She sought out one of the leaders involved with Jordans, D'Wayne Edwards, and asked him how she could help.

"I think that really set me up in my career," she says, "learning that you kind of just have to do things. You

can't wait for anyone to tell you what to do; you have to have a vision for yourself."

Eventually, Cheresse designed the shoes she once couldn't afford. And she was one of the first Black women at Nike to do so.

Cheresse says she got there by staying focused on what she wanted and constantly reading books about people who did things she dreamed about.

"I have more books than shoes," she says, "and I have a lot of shoes."

She also says that learning as much about her dream job as she did her craft also helped a lot.

"Whatever you want to be," she says, "find out how that person spends their day and prepare yourself as much as possible for what you want. There are a lot of barriers, but I think we can be anything."

Though even she doubted her own belief sometimes.

"I did have those moments," she says, "when I allowed other people's perceptions of me to kind of get into my head. I had to guard my heart against that so I could stay clear and not allow other people's fears to become my fears."

She says it was surreal to have a dream she wrote down as a kid come true exactly how she wrote it. She also couldn't help but wonder, *What's next?*

"But we have to keep going," she says. "Once you attain one dream, write down another one."

✸ YOUR OWN TIMELINE
(CHANNEL BAEZ)

Channel Baez dreamed of being the first woman in her family to get a bachelor's degree. But when she got pregnant in high school, that started to seem impossible. Her teachers certainly thought so; one told her she would never amount to anything.

Channel wanted to prove them wrong—that she didn't have to give up on her dreams just because she made one mistake.

After high school, while raising her daughter as a single mom, Channel enrolled in college. It was difficult, especially because, she says, at the time it was hard to find any other single moms doing what she was doing. She knew it might take her longer to graduate than those around her, but, she thought, this was her dream and no one else's. It would take as long as it needed to take.

Ten years later, Channel graduated with her bachelor's degree. And when she did, she had a new dream—she wanted to go to graduate school. By then, she had a partner and two kids, so it seemed possible. And then her partner left suddenly and she was a single mom again.

"I was in such a deep hole that I didn't see any kind of solution," she says. "I was so depressed to the point that if I didn't wake up the next day, that was fine with me."

But she found resolve in the eyes of her kids. She remembered how, even though it had taken ten years, she'd accomplished a dream during an impossible situation before. She could do it again.

"I made a decision," she says. "Even if I am going through a hard time, even if my heart is breaking, even if I am dying in agony, I am going to change my life."

She also knew she needed to take care of herself, to rest and recover from this sudden blow. Channel booked a solo vacation to the Dominican Republic to give herself some time and space to grieve and recalibrate. The time away, and alone, refreshed her. When she got home, she made a list of all the things she wanted to change about her life.

Graduate school was still at the top of the list. She applied, got in, and worked toward her graduate degree while raising two kids and working full time.

Channel graduated with a master's degree in 2016, and when she did, she couldn't help but remember how isolated she had felt when she first started college, not seeing any other single moms in her classes. Reaching her dream of a bachelor's degree, and now a master's, showed her, she says, that not seeing anyone like you doing your dream "doesn't mean you're not capable of working your way toward that," no matter how long it takes.

✷ WHEN YOU LOSE HEART
(JOHN MUSKER)

Every few weeks, seven-year-old John Musker walked into the library to return *The Art of Animation* by Bob Thomas and then check it out again. He dreamed of doing what the people in those pages did—draw for a living. That book made it seem possible. So did his mom, Joan.

When he was a kid, his mom commissioned him to paint a big tree above the picnic table she used as their dining table, so that they'd always feel like they were dining alfresco, even during the brutal Chicago winters.

"She was big on creating an alternate reality," he says, and he wanted to do that too with his art.

So in college, when he learned that Disney was looking for animation trainees, he got right to work on creating his portfolio. When he thought about what to draw for Disney, he thought, *Animals*. He headed out with paper and pencil to the Lincoln Park Zoo in Chicago. In February.

John sat on a bench to draw the monkeys, but his pages blew away in the icy wind and his hands seized beneath his gloves. It was too cold. He needed another idea. *Why don't I just go to the Field Museum of Natural History and draw from the animal exhibits there?* he thought.

After that, he sat in the warm museum and carefully drew the animals behind glass. He then put those drawings in an envelope and excitedly sent his portfolio off to Disney. His dream was about to come true. He could feel it.

He was thrilled when he got a letter in the mail with a return address for Disney. But his heart dropped when he pulled out a single page rejection letter.

It wasn't a form letter though; they gave him direct feedback, sharing the reason he was rejected: "Your animal drawings are too stiff."

He can laugh about it now, saying, "Of course, they were—they were stuffed!" Back then it really did hurt, but he didn't let how bruised he felt keep him from using the feedback to grow his dream.

When he studied his own drawings of the stuffed museum animals, he noticed they were suspended, without weight, without gravity. "If animation is not done properly," he says, "it looks like it's floating." But that's not what most animators are going for; a sense of gravity is vital to making a drawing seem *alive*.

But John didn't know that then. So instead, he thought maybe he should just try drawing something else. He drew comics next and sent off a new portfolio to Marvel. He was rejected again.

And then, another letter from Disney showed up in the mail. This one was about a new character animation program starting at CalArts, that would be taught by veteran Disney animators.

John wasn't sure if he should apply. California was far away, and he'd never left Chicago. He also hadn't planned on graduate school; he had already spent four

years in college. He was ready to work, not go back to school.

But he knew deep down that his drawings were still missing something. Why not find out what that was and try to get better, especially if he could learn from the people he'd always admired?

John applied, and in 1975, he started at CalArts, where he learned how to make art come alive. Two years later, he got an internship at Disney Animation and then a full-time job, where he met and became fast friends with Ron Clements. Together John and Ron wrote and directed *The Great Mouse Detective*, which was released in 1986 and made millions.

It was a dream come true for John, not because of the money but the people. For him, the dream come true was getting to see so many people react to and enjoy a film he helped create.

"There are many artists who create solely for the act of creating," he says, "who could be in a room alone and create art and it doesn't matter if anybody else sees it. I'm not that person. I have to show it to somebody. I have to get a reaction."

Although that often means some reactions, just like his initial rejections, aren't always positive. Many of the films John has made go through a testing process early on, and John has been on the receiving end of *a lot* of critical feedback from colleagues and focus groups.

"Many of the best films," he shares, "go through periods where it looks like they are going to be the worst film ever made."

It's hard to maintain your creative vision when you're in a phase of getting constant feedback, when

every time you share your work it comes back with more notes, more changes needed; instead of seeing that as progress, you can start to feel like it's proof that what you've made is actually bad, that you're bad, and that your vision, your dream, will never be a reality. It's a battle John faced with every new film he went on to direct—the battle to not only hold on to faith in the work but also himself.

The only way he was able to get through that phase was to remind himself of his initial vision, remind himself what it looked like and how it made him feel, before things got messy, before people started sharing their opinions. In the middle of every project there was always a time when he would have to specifically remind himself again *why* he wanted to tell this story in the first place. He'd dig through all the dirt the journey had piled on thus far, grasping again for the original spark—that's what always powered him through the final steps of each film.

And once he did that, it was actually easier to look at the work objectively again, understanding that most of the feedback wasn't there to tell him how wrong he was or how bad his work was. Feedback was actually a gift— it meant that there were other people who saw enough in what he'd created from scratch that they wanted to help him get closer to the vision he had all along.

The "problems" that kept coming up toward the end of a project, he came to understand, were not a sign he'd done it all wrong but actually a sign that he was getting closer, that there was something real now instead of just a vision, something other people could see too. When he really considered the feedback as a whole, he saw that most people saw his vision as one worth unearthing, and

their comments were simply pointing out the last things in the way, the things we often can't see when we've been close to a project for a long time.

"Most creative problems can be solved," John says. What helped him most with the things he was stuck on was showing his work to people he *really* trusted, the people he thought had a good eye.

"I'd be vulnerable," John says, "and show it to someone and ask, 'What do you get out of this?'

"This is always a risk," he says, "because that person may not get anything out of it, so doing that does take a fair amount of courage."

But getting an outside perspective from people he trusted always helped him slowly but surely come back to the objectivity that almost every artist loses at some point, because the act of making something with your whole heart almost guarantees there will come a point when you're in too deep to see it clearly. That's part of the process of making something great, and that means you have to have the courage to dig back out when it's time.

John practiced this his entire career and, along with Ron, went on to write and direct movies like *The Little Mermaid*, *Aladdin*, *Hercules*, *The Princess and the Frog*, and *Moana*, all of which, he says, had their own challenges and moments of crisis before they became the films we know today. But he says he and Ron were always fueled by the passion of their original vision to keep going; with every film they knew even more about how to solve the problems to make the film they envisioned in the first place.

Though John's biggest dream-come-true moment didn't happen in a theater, or even in the animation offices: it happened on his front steps.

It was October 31, 1990, and his doorbell rang.

"Trick or treat!" a small girl said sweetly. John looked down and noticed she was wearing a mermaid costume. She was dressed as Ariel, the main character from *The Little Mermaid*.

For him, that was the biggest dream-come-true moment, when he realized his movie had a life beyond a few weeks in a theater. When he first joined the studios in the 1980s, it seemed like animation was dying and that movies would only live for a few weeks and then dissipate. That was always disheartening to him. He wondered early on if he'd ever be able to make a lasting impact with his films, like the ones he'd grown up watching and still cherished.

That little girl showed him that the film he made meant enough to someone else to make it a part of their life long after the movie left the theaters. Because he followed the spark of a vision all through the highs and lows of the creative process, seeing each film through to the end, working to solve every problem and chip away everything in the way of the original vision, that original spark was able to transfer, to spread.

In 2018, I sat on his front steps waiting for my ride-share after our interview. He told me to wait there and that he'd be right back. He wanted to give me something before I left, especially after I'd just told him what *The Little Mermaid* and *Moana* specifically had meant to me.

He returned with two signed movie posters of each film. On *The Little Mermaid* one he wrote, "Thanks for being part of Ariel's world, and mine." And on the *Moana* one he wrote, "Who knows how far you'll go . . ."

✱ EVERY NO ISN'T NO FOREVER
(NICO DEJESUS)

Nico DeJesus started dancing and playing sports when he was four years old. But by the time he was in middle school, his parents couldn't keep up with driving to so many activities, so they asked him to choose one. He chose dance.

In high school, his musical theater teacher taught him about how dancing, acting, and singing on stage could be a job. He dreamed of being a performer for a living, and his teacher showed him it was possible; people *did* have that job. But he knew to even have a chance at a job like that, he'd have to be *really* good. So he decided to take what he'd learned from sports and practice acting, singing, and dancing just like he did with athletics.

He constantly practiced in front of the mirror, assessing and improving, and was always asking teachers for feedback on how to get better. And when he felt he'd learned all he could, or noticed he was the "best" dancer or actor in a class, he'd leave that class and find another.

"I never wanted to be the best person in a class," he says. "It's when you're not learning that it's time to second-guess what you're doing." He took the best classes

he could find and worked whatever jobs he could to pay for them.

Nico went to college at UCLA and studied dance and then worked at the UCLA bookstore when he graduated, a position he calls his "survival job." He says it paid for the Nutella sandwiches he lived on during that season of unfruitful and grueling auditioning.

"There were so many times in LA after an audition," he remembers, "where I'd just sit in my car, head down, phone off. I didn't want to talk to anybody for a week. I just wanted to give up so many times."

His life took on a painful rhythm: rejection, rejection, Nutella, rejection.

Then one day a friend called and told him that someone in the Broadway cast of Disney's *Newsies The Musical* was leaving, and, to fill the role quickly, auditions were being held across the country, including LA. This was Nico's dream job, so he auditioned.

He made it past the first round, then the second, and then made it to the final round.

Then he waited to hear back.

And waited. And waited. And waited.

When he couldn't take it anymore, he finally broke down and called his friend in New York to ask if he'd heard anything.

"Did they book someone for that job yet?" Nico asked.

"Yeah," his friend replied, "they booked someone two weeks ago."

Nico was crushed.

But then, after he got through the initial disappointment, he decided to send a letter to the casting company to thank them for the opportunity; he knew it was a privilege

to get that far and get to learn *Newsies* choreography, and he genuinely wanted to say thank you.

At the end of the letter, he asked them to keep him in mind if anything else ever opened up. And that was that.

Nico went back to working at the bookstore, but he felt deflated. After all these years of focusing on dance and his dream, he still felt so far from where he had hoped to be. Maybe it was time to think about doing something else with his life. He bought books on how to become a personal trainer from the bookstore where he worked and then on a whim applied for a job with Apple. He got an interview, and then another. But in the final interview, he thought, *What am I doing here? This isn't it.*

That's when he knew he wasn't ready to let his dream go. And at least now he knew.

He kept his job at the bookstore, kept going on auditions, and kept taking the best classes he could find.

Three years went by, and still, he was working at the bookstore.

But then one day he got an email from the New York casting company he'd auditioned for three years before, the one he'd written the thank-you letter to, the one that had been casting for *Newsies The Musical* on Broadway. They were writing to let him know *Newsies The Musical* was about to go on tour. Would he be able to fly to New York in a month to audition for the touring cast?

They remembered him.

Nico booked a flight for New York for the following month and spent the next four weeks training like he'd never trained before, dreaming daily of what it would be like to join the *Newsies The Musical* touring

company, imagining himself on stage. He knew the first show of that tour would happen at Proctors Theatre in New York in October. So he wrote in a notebook: "On October 11, 2014, I will be performing at the Proctors Theatre in New York on 432 State Street." He read that line every night before bed.

He also read it the morning of his audition in New York. When he walked into the audition room, he saw ninety-nine other incredible dancers there to audition. He knew this was still a long shot, but he gave it his all, using everything he'd learned in his twenty-one years of training. Anything they asked him to do, he could do.

The audition ended, and they told the dancers they'd hear back once final casting decisions were made. When Nico walked out of the building all he thought was, *I want fries.* He'd been eating "perfectly healthy" during training, so the first thing he did after the audition was order fries and soda from the first fast-food place he walked by. When he walked out, it was raining. He thought it was a sign—and not a good one. He kept walking and ate his now-soggy fries in the rain.

Nico flew back home to San Diego. Days went by, and the phone didn't ring. By this time, Nico had an agent, so he called him to ask if *he'd* heard anything. He hadn't.

That was it then, Nico knew. He wasn't going to get it.

Then, his agent called him. "They wanted to say thank you for coming out, you were really great—" he started.

"I didn't get it, did I?" Nico interrupted, needing to get it over with, confirm what he already knew.

"No," his agent stopped him. "You got it. You're going to be on the *Newsies* first national tour."

Nico cried.

And on October 11, he performed on the Proctors Theatre stage in New York City on 432 State Street. He also performed his role for the film, *Newsies: The Broadway Musical.* Six minutes and fifty-eight seconds into the film, Nico appears as his *Newsies* character, Romeo, cheeks smudged with dirt, smiling as he sings and dances on stage.

★ GOING THROUGH THE FOG
(ANGEL SANCHEZ)

Angel Sanchez grew up an only child in Miami, Florida, raised by a single father who had to spend most of his time away from home, working as a tow truck driver. Angel was lonely, and, longing for a sense of family, he clung to the first thing he found that felt like one—the gang he joined when he was thirteen years old. In 1998, when he was sixteen years old, because of his gang involvement, he was arrested, tried as an adult, and sentenced to thirty years in prison. But even that didn't feel like the end of the world to him then because his world was still so small.

"I didn't really understand what I had lost," he says. "I was just going through the motions of the lifestyle I was living, and this was the inevitable result."

Jail was part of the familial gang culture he'd found himself in.

"We go to prison," he says of his mentality then. "Some of us get out and go back, and some of us don't, and this is what it is."

Angel didn't have dreams then. But his dad did.

His dad had always dreamed that his son would get an education, and he told Angel this all the time. And

even though he was in jail, Angel still wanted to make his dad proud. In prison, he focused on getting his GED. And when he did, his dad was so proud.

Soon after, Angel's dad died, but his dream had a lasting impact. While studying for the GED, Angel had fallen in love with learning.

"I developed an appetite for it," he remembers, "almost an addiction."

From then on, he spent every day in the prison law library, reading *everything*. Angel developed an aptitude for the law, and for the first time in his life, he made *himself* proud. For the first time in his life, he wondered if he could be more than what he had seen where he grew up.

But then he was filled with regret and sorrow, for the choices he'd made when he was younger and for all he'd never known. *I wish I would have known this before*, he thought. *I wish I had been exposed to this before.*

This new potential he saw in himself was also kind of scary; he had always thought he knew what his life would look like: he'd get out of prison one day and go back to the only life he knew because what else would you do when you got out of prison but go home?

But now that he had new dreams to consider, he knew he couldn't go back. Instead, he dreamed of getting out of prison, going to college, and starting a new life, one where perhaps he could make an impact on other kids like him.

Though his release date was still decades away, his hope made him resourceful. *If I can't get to where my dream is,* Angel thought, *then I'll bring my dream to me.* He ordered college textbooks to study in prison and created his own curriculum, even giving himself essay assignments and deadlines.

"I became my own professor," he says.

He also became his own lawyer. He found and signed up for a correspondence course on becoming a paralegal and researched the details of his case in the prison's law library. An older incarcerated friend of Angel's, who also worked at the law library, noticed Angel's dedication and convinced the head law librarian to hire Angel as a law clerk trainee, "despite the fact," Angel says, "that I was a stereotypical inmate they did not want; I was the teenager, gang member, troubled. But I was able to offset that with love, showing the love I had of the work I was doing through my work ethic, by reaching out and doing my part, doing the legwork. If you get the legwork done, it helps people help you."

His job as a clerk trainee was the first job Angel ever had, and he *loved* it.

And now he had even more opportunity to study his case. But the more he did, the more discouraged he became, seeing how difficult it would be to try to work his case alone. *I'm never going to get out*, he thought. He made space for that feeling, but he didn't let it stop him. He figured he didn't have anything to lose if he tried, so he tried to get an appeal. But he got denied.

He tried again, but got denied again.

He was allowed only one final appeal, and if that didn't work, he for sure wouldn't walk out until 2028.

"I was broken," he remembers, knowing final appeals almost never worked.

He was resigned to his fate, but wasn't ready to let go of his dream.

"I came to terms that if I had to do this sentence, it was okay," he says. "If this part of my dream didn't

come true, I was okay. I would just achieve my dream in prison. I would find a way to become college-educated. I would find a way to write a book from prison or do something to somehow impact society in a positive way. I came to terms [with the fact] that a part of my dream may not come true; but coming to terms and becoming complacent are two different things. I still fought, but I fought with peace."

And then, to his surprise, his third appeal got his sentence reduced by fifteen years, and in 2011, he got out of prison.

He didn't know where to go next; he only knew where he didn't want to go. He knew what sent most people back to prison was going back into the same environment, only with fewer job opportunities than before because of their prison record.

Angel knew he couldn't beat the statistics if he did what everyone else was doing. So instead of going back home to Miami, he decided to move into a homeless shelter he found in Orlando, Florida.

But then he found out the shelter wouldn't support him if he pursued a college education; they would only provide him shelter if he got a full-time job. He felt trapped and lonely, already feeling the pull to return to Miami.

"You have these two worlds side by side," he says. "One pulling at you to come back, the other rejecting you, which also makes you want to go back."

Angel tried to get a job so he could stay at the shelter, but no one would hire him. "Everything seemed so bleak," he says of that time.

He decided to go back to Miami.

But right before he left, a place in Orlando literally called "Flippin' Burgers" hired him for part-time work, his first job in the "real" world. Angel was thrilled; he could work part-time and enroll in community college part-time.

Except if he did that, the shelter would kick him out. They would only support him if he had a full-time job. He didn't think he could survive in a new environment without any housing, any support. He would have to go back to Miami after all.

But then, an assistant manager at the shelter (also a former correctional officer) noticed Angel's drive.

"He could appreciate the hard work I was putting in and how rare it was," Angel says, "so he advocated for me." The assistant manager convinced the shelter that part-time work was a big step for Angel, who had never had a job outside of prison, and that going to school as well was a good thing.

Angel was secretly still thinking about moving back to Miami, though; the loneliness was getting heavier.

"At that point," he remembers, "I was dying to have an excuse for my dream not to come true so I could have an excuse to go back to the world I knew. At least there I would be loved. In Miami, in my old life, people knew my name. Here, no one knew me."

But Angel stayed in Orlando and enrolled at Valencia College where he got a work-study position in the financial aid office that helped him afford school. They liked him so much in that office that when a financial aid specialist position opened up, they encouraged him to interview and apply. But unlike work-study positions, this one would require that he disclose his criminal history; he wasn't

likely to get clearance for the job. However, the financial aid office talked to HR, and they said that if the president of the college signed off on it then they could hire him.

"I was scared to ask him for the recommendation letter," Angel remembers. "I was scared of rejection. I was scared to get turned down." He was also scared to get proof that he was unwanted.

But luckily, his lawyer side kicked in again, and this time, he countered by considering how far he'd come. *Angel*, he said to himself, *you're being considered for a financial aid position after twelve years in prison; that in itself is an achievement. Part of your dream was to get out. You've achieved that part. Part of your dream was to go to college. You're doing that part.* Angel had become so used to dreaming, to always looking ahead (and thinking about how far he had to go), that he often forgot to look back at how far he'd come.

Angel told the president of the college his dream and asked if he'd be willing to write a recommendation letter for the financial aid specialist position. He held his breath as he waited for the president to reply.

The president said he wouldn't write the letter. Instead, he said, "I'm going to call HR personally," and he recommended Angel on the spot.

That breakthrough, happening right as he was thinking about giving up again, reminded Angel of how he felt just before his sentence got reduced, and now he knows how normal it is to darkly doubt your dream just before it comes true.

"It's like people sailing in fog on the ocean," he says, "who are like, *Oh my gosh this is it. I'm going to quit.* And little do they know that right beyond that veil, right

beyond that fog, land is there. They can't see it. But if you just break through that, you'll be like, *Dang, I'm glad I didn't quit. It was right here.*

"I think part of that is because right when you're closest to achieving your dream is when the stakes are highest. If it doesn't happen now, everything you've done up to that point feels like it's going to go to waste."

When you feel like you've given everything you have and it's *still* not enough, giving up simply seems like the last thing you can control, like the only choice that's even yours.

And while Angel had a lot of will, what ultimately powered him through the fog was the support of others. "When one person's will to succeed is finally met by another person's compassionate support," he says, "amazing things happen."

By the time he was thirty-two years old, Angel graduated from Valencia College, where he was honored as a distinguished graduate and asked to give the commencement speech. He opened his speech thanking the college staff, thanking the family and loved ones in the audience, and then congratulated the class of 2014; everyone cheered after his intro, then he laughed and said, "Started from the bottom, right?" He continued, "I must confess . . . I've never graduated from anything before."

He then mentioned all of the other inspiring stories he knew were in the room, saying, "We arrived here with baggage, with challenges, with difficulties, and today we leave with a degree."

Angel went on to get two more degrees from the University of Central Florida, and he finally did go back to Miami—for law school.

CONCLUSION

One night during a time when I'd written almost all of this book except for the conclusion (because I still had no idea how to end this), I got another text from my best friend Erin: a short video she wanted to share of her two-year-old daughter Addy's first swim lesson. In the video, the swim teacher's dark curly hair is pulled up in a ponytail; she holds Addy beneath the shoulders, and gently dips her underwater. But as Addy comes up she takes a sharp inhale a little too soon, coughing a few times and crying. But before Addy can panic, the swim coach calmly says, "Good job, Miss Addy—good job."

The teacher then turns to Erin and tells her that they'll spend a little more time on breath work today, to help with the coughing. She dunks Addy again, and then pulls her up. Addy coughs and cries again, but a little less than the first time. While she's crying, the teacher holds her and softly says, "Good job, baby girl. You're doing so good."

Then she looks Addy in the eye to find out if she's ready to try again. "Are you ready?" she asks. Addy lets out a whimper, wipes her eyes, and then stops, looks

at her teacher, takes a breath, and nods her head ever so slightly.

They go under again, and Addy coughs and cries, but only for a second this time. She wipes her eyes as her teacher says, "Fantastic Addy! You are doing such a great job. Such a brave girl." She asks Addy if she's ready to try again, and this time Addy nods even sooner.

I texted Erin back immediately, saying, "We all need people like that telling us *good job* when we're being brave and feel like we're drowning but are really just learning, don't we?"

Toward the end of the video, Addy is able to go under the water and rise again without crying or coughing. Once she does that, her teacher says, "You're gonna take my hands this time, okay?" Addy nods and the teacher removes her hands from beneath Addy's shoulders and holds Addy's hands as they both stretch out their arms. Addy is a little farther away from the teacher now, but the teacher looks at her across the water between them and says, "You think you can do it? I think you can do it. Are you ready?" Addy nods. "Hold on," the teacher says softly, her last piece of advice. Then Addy willingly dips her head below the water, and quietly rises.

To stay in touch, join my Keep Going Club newsletter at isaadney.com/keepgoing. And if you liked this book, it would mean so much to me if you shared it online. If you do, please tag me at @isaadney so I can say thank you.

ACKNOWLEDGMENTS

In many ways this book is a dream come true for me, and the first person I need to thank is you. The thought of you, reading and finishing this book, is my dream come true. Thank you so much for taking the time out of your busy life to spend hours with me and the people in this book. I can't wait to hear what you got out of it and where your story goes next.

And, as I hope you gleaned from this book, dreams don't come true without help. And to make this book, I had *a lot* of help.

First of all thank you to Brooke Warner and every one at She Writes Press who believed in this book and helped bring it to life.

Thank you to the faculty, staff, and students at the Vermont College of Fine Arts. Getting an MFA there has been one of the highlights of my life, and I spent the first year of that program working closely on this book. A special thanks to my advisers that year, Geoff Bouvier and Negesti Kaudo, for helping me find the final shape of this book.

Thank you to everyone at ConvertKit for being such a wonderful place to work while I wrote this book, to Nathan Barry for inspiring me always, to Henry Thong for showing me I wasn't alone in wanting to spend my free time profiling creatives, to Dani Stewart for being such a fabulous editor, and to Charli Prangley for making a Keep Going Club logo on a plane and being the first person to interview me on camera about this book, long before I even wrote it.

Thank you to everyone in the Mammoth Club for keeping me laughing about DCOMs and potatoes; you kept me climbing during some of the hardest parts of finishing this book.

Thank you Jessica for the audio message you sent me that kept me going when I felt like I was going to fall apart (along with this book).

Thank you Jenny for taking the time to email a stranger and give her the encouragement that would keep her going for years.

Thank you Erin and Alice for all the long conversations and sleepovers. Whenever I doubted this book, I remembered that my first book brought me to you; no matter what happened, I'd remember that finishing and sharing books could bring the greatest treasures, and I'd keep going.

Thank you Megan for allowing me to share yours and Cam's story. The love you showed Cam and the courage you showed in the midst of the greatest loss will stay with me forever.

Thank you Maureen and Hadley for showing me that even when dreams don't come true they still matter.

Thank you Carly, Amma, and Brittany for the best virtual conversations during those years I spent in San

Diego. I can't imagine my life or this book without you or that precious season.

Thank you to everyone who read pieces of this book before it was ready.

Thank you Emily for being the best friend and writing companion I could ever hope for. San Diego gave me so much, but I'm most thankful that it gave me you. Can we please do another bonfire on the beach soon?

Thank you to my beta readers, Jessica, Karen, Juliet, Whitney, Jarid, Jessica B., and Angel. Thank you for reading the book in one week and giving me encouragement that powered me through this last phase.

Thank you Don Hahn for believing in me and showing me what it truly means to be an artist.

Thank you Paitoon for saying yes to the very first interview I ever conducted for a piece of writing. Thank you for meeting me at that Lake Mary Starbucks and letting me into your creative world.

Thank you Kristen Anderson-Lopez for being the writer and artist you are. You and Robert sharing your creative process on a D23 stage in 2015 changed everything for me, and inspired me to start Creative Teacup. Thank you for your generosity in sharing your story with me and for being in this book. To say the words in the songs you've written have kept me going would be the understatement of the century.

Thank you to everyone I interviewed for Creative Teacup and for the profiles and films I made for Convert-Kit. Those conversations and profiles kept me going and played a role in inspiring the heart of this book.

Thank you, Will Wells, Seth Stewart, and Anna-Lee Craig, for inviting me backstage and onstage to meet

everyone in the original cast of *Hamilton* in 2016. Shaking hands with Lin-Manuel Miranda that night was a moment I returned to again and again whenever I questioned whether I belonged, whether I could really do this.

Thank you Paulo Coelho for writing *The Alchemist* and inspiring me to pursue this and many other dreams.

Thank you Steve Lewis for making cookies that helped *me* when I was sad and for making both your dreams and Gideon's dreams come true, showing me what can happen when you have the courage to be yourself and share what you love most.

Thank you to every rideshare driver and café barista who asked me about this book and gave me the chance to say out loud that I was a writer and to talk about this project in a way that helped it feel more real. And the conversations we started about *your* dreams inspired me more than you know.

Thank you Zac Hill for being the very first person to say yes to interviewing for this book. That interview helped guide the rest of the process, and your enthusiasm and electricity fed the spark of this idea.

Thank you to all 120 people who gave me their time and energy for an interview. While I was not able to use all 120 stories in the book, this book would not be what it is without every single story and conversation. Thank you for your courage to pursue your dreams and your generosity in sharing them with me and everyone who reads this book.

Thank you to everyone in this book who gave me even more time to do fact checks and help me with all the final pieces. Thank you for your care and attention and generosity. Thank you for believing in me. Thank you for letting me share your story.

Thank you to my mom and dad for always believing in me.

Dad, you put it into my head that people should do what they enjoy. Even when the world made it seem like that was impossible, your voice and the seed of that idea kept me looking and hoping for more joy.

Mom, you believed in me as a writer long before I did. It's easy to think that's just because you're my mom, but I know now having a mom who loves and believes in me is one of the greatest privileges in the world.

Tito and Robby, thank you for being the best brothers and for all the joy and laughs and conversations about art and video games.

Alyssa, thank you for being the most incredible sister-in-law and mom to Oliver and Isla. Most of my dreams now pretty much just revolve around taking them to Disney (and of course profiling Taylor Swift—but I'll also take dancing with them to Taylor Swift music videos in the living room).

Thank you Becky for all of your love and encouragement and hugs, and for showing me that even when it seems like everything is out of your control you can always pick up a hammer and put in new windows.

Thank you Barbara for being my fellow book lover, and for the way you light up when people you love walk into a room. You have shown me what it looks like to love even in the darkest of times.

Thank you Gary for being the person I could always talk to about art and the person who believed in me as an artist and talked to me like I was an artist long before I even saw it in myself. I love you and miss our kitchen chats.

Thank you Jeremy for being the best partner and husband I could ever hope for. Thank you for supporting this book all these years. I know being married to an artist-type can be a roller coaster, and I'm so grateful for the ways you steady, encourage, and ground me. But most of all, I'm thankful for all the fun we have every single day.

And finally, though I know you can't read, thank you, Stanley, for being the best and cutest dog in the whole world. You taught me that some of the greatest joys in life are warm hugs, long walks, and having someone in your life who's happy you're home.

ADDITIONAL RESOURCES

For free resources, including journal questions themed to each chapter, a book club guide, a recommended reading list, and more information about the interviewees, go to isaadney.com/dreambook.

ABOUT THE AUTHOR

I sa Adney is a writer, dreamer, and storyteller, and one time she shook hands with Lin-Manuel Miranda on the *Hamilton* stage in New York City. (She just had to throw that in.)

She has interviewed many creatives, artists, and dreamers and written dozens of full-feature profiles and counting. You can read those stories on her blog *Creative Teacup*.

She's also written dozens of profiles for ConvertKit and is the host of the *I Am A Creator* podcast and producer of the *I Am A Creator* docuseries, which won six Telly Awards.

She currently lives in Orlando, Florida with her husband, Jeremy, and her dog, Stanley. When she's not walking Stanley, reading, writing, or listening to Taylor Swift albums, you can usually find her at Disney.

Author photo © Ashley McCormick

SELECTED TITLES FROM
SHE WRITES PRESS

She Writes Press is an independent publishing company founded to serve women writers everywhere. Visit us at www.shewritespress.com.

Finding the Wild Inside: Exploring Our Inner Landscape Through the Arts, Dreams, and Intuition by Marilyn Kay Hagar. $24.95, 978-1-63152-608-4. What might it be like to step away from your busy life and figure out what truly gives your life meaning? This book encourages readers to discover that wildly creative place inside that knows there is more to life than we are currently living— and that life lived from the inside out offers us a path to authenticity and belonging.

The Art of Play: Igniting Your Imagination to Unlock Insight, Healing, and Joy by Joan Stanford. $19.95, 978-1-63152-030-3. Lifelong "non-artist" Joan Stanford shares the creative process that led her to insight and healing, and shares ways for others to do the same.

Think Better. Live Better. 5 Steps to Create the Life You Deserve by Francine Huss. $16.95, 978-1-938314-66-7. With the help of this guide, readers will learn to cultivate more creative thoughts, realign their mindset, and gain a new perspective on life.

This Way Up: Seven Tools for Unleashing Your Creative Self and Transforming Your Life by Patti Clark. $16.95, 978-1-63152-028-0. A story of healing for women who yearn to lead a fuller life, accompanied by a workbook designed to help readers work through personal challenges, discover new inspiration, and harness their creative power.

Your Turn: Ways to Celebrate Life Through Storytelling by Dr. Tyra Manning. Operating from the premise that writing about life experiences offers a new perspective that can aid in healing old traumas and wounds and in celebrating the joys of fond memories, this inspirational workbook encourages and supports readers in exploring their experiences and feelings on the page.

Big Wild Love: The Unstoppable Power of Letting Go by Jill Sherer Murray. $16.95, 978-1-63152-852-1. After staying in a dead-end relationship for twelve years, Jill Sherer Murray finally let go—and ultimately attracted the love she wanted. Here, she shares how, along with a process to help readers get unstuck and find their own big, wild love.